# Acrylic Expressions

## Painting Authentic Themes and Creating Your Visual Vocabulary

**Staci Swider**

**NORTH LIGHT BOOKS**
CINCINNATI, OHIO
www.artistsnetwork.com

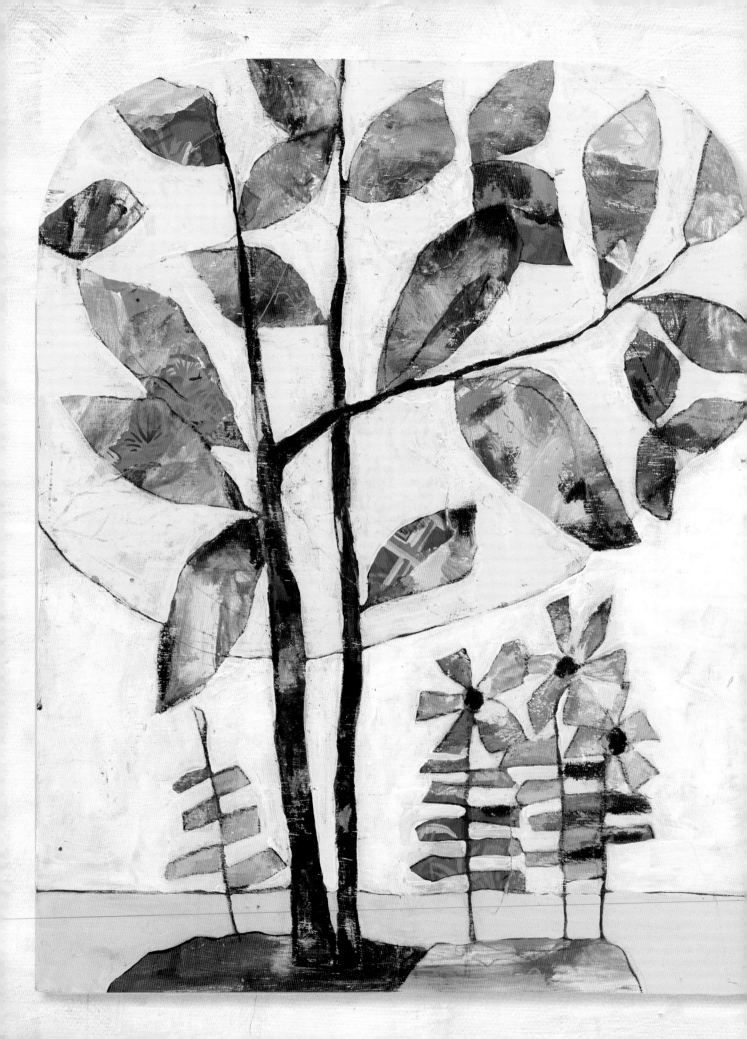

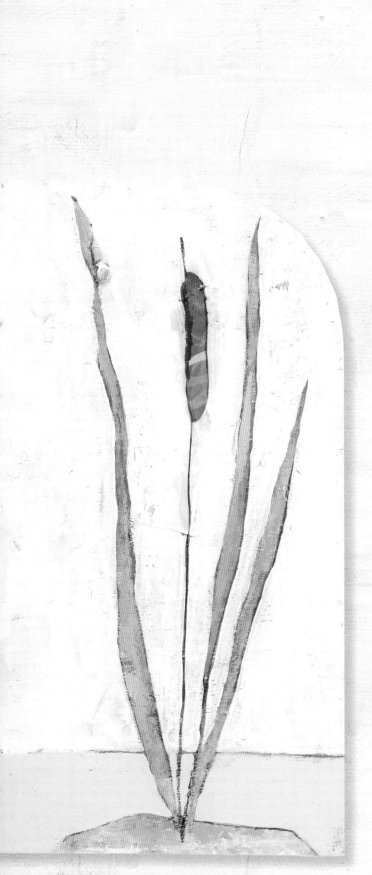

# Contents

# Introduction

Thank you for opening these pages and allowing me to be a part of your artistic process. Our journey as artists is to break new ground personally and artistically, and on the pages that follow I will take you through my own artistic process. Hopefully along the way you will find a nugget of inspiration that either confirms your current path or maybe sends you down some totally new alleyway you'd never considered and brings all of the excitement that comes with such a trip. This book is a collection of methods for working intuitively and organically in order to let paintings evolve rather than push a preconceived idea. I also share ideas for inspiration as well as a glimpse at my own influences. That being said, what is important to me as an artist may not necessarily be important to you, but my hope is that by my leading through example you will see what catches my attention in the world around me and how that spark leads to finished artwork that evolves by and large intuitively.

We've all heard it said that the more you practice your craft, the more automatic it becomes. This couldn't be more true when it comes to working intuitively! Sketch everything. Record your world in quick 30-second sketches while waiting in line at the bank or while taking a quick break at your desk. The more you work in your sketchbook, drawing the things around you, the better. You will learn to create your own personal drawing alphabet, and putting together a composition out of seemingly random strokes of color on the canvas becomes as easy as writing your name. When you draw a beautiful flower for instance, draw it over and over again until it is reduced to its basic parts, the shapes that are the most important to you. What you end up with is a personal symbol of that flower that is totally and uniquely *you*. This is what you are after—colors and mark making that become *your* own story.

When I paint, it is not my intention to recreate the landscape exactly as I see it, but rather to allow those images to imprint upon my psyche and then filter out into my paintings. I sketch what I see, repeatedly, sometimes ten to twenty times. Then when I begin a new painting that idea is in the back of my mind. As I drip paint and add large dobs of color, that subliminal idea starts to take hold, sometimes literally as it was in my sketchbook. More often what happens is that several ideas from different sketching pages get tangled up and show themselves as a totally new composition on the canvas. The paintings contained in this book are presented merely as a starting point and as examples of particular techniques that can be applied to tell your own story. Dripping paint down a canvas to divide it horizontally or vertically can be used for all manner of compositions, not just landscapes or flower placement. Consider a crowd of people on a page. Or merely a way of making a plain background more interesting by painting tone-on-tone stripes.

All of the paintings are created in layers, and the projects in the following chapters build in complexity somewhat as you go from first to last. Take a minute to scan through the entire book and see how one technique builds upon another. This will give you a better understanding of how the paintings are also built, one layer upon the previous. Then feel free to jump in wherever you feel comfortable and just *do*.

Creating is a joy and there are no mistakes. If you don't like something you've created, paint over it. Every experiment is a lesson in what works and what doesn't. Instead of focusing on the product, give yourself permission to play and focus on the process. You are an amazing human being and we are all on this creative journey together. So what do you say? Shall we begin?

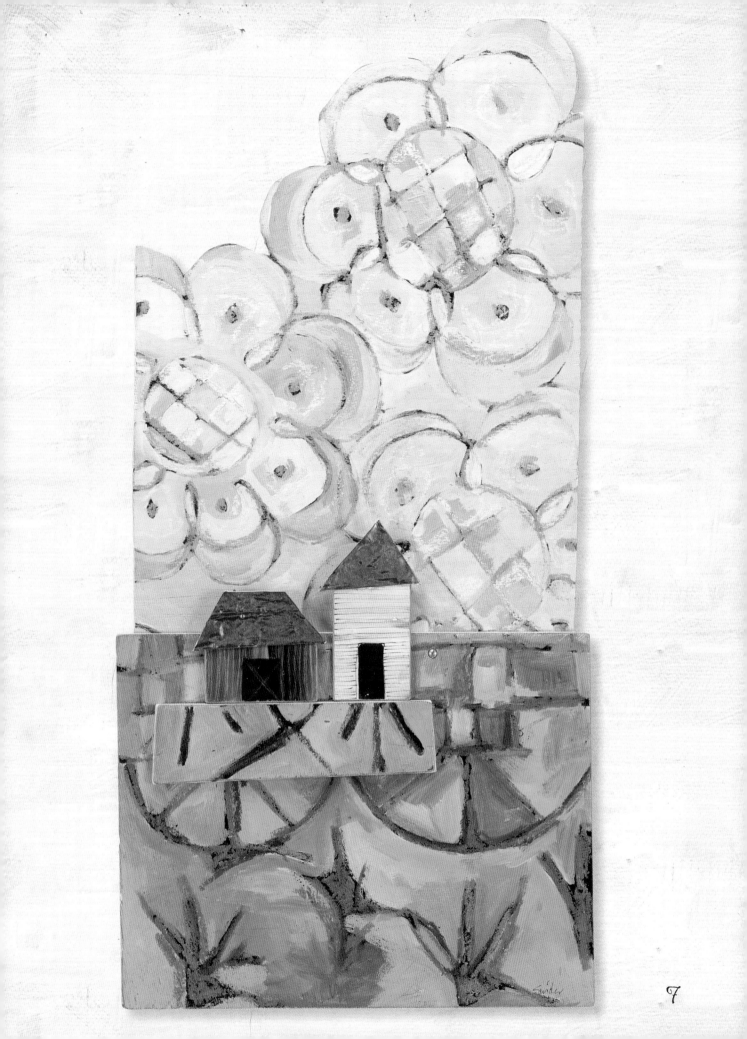

7

# CHAPTER 1

## Aspects

I love art that bears the mark of the maker: loose lines, heavy brushstrokes, even fingerprints. I want to feel the artist's presence and energy when I look at a piece of art. I'm drawn to the extremes in artwork such as thick, chunky paint and texture wielded with reckless abandon versus subtle, soft nuanced color presenting an ethereal vision.

Color can make or break a piece of art and all too often people rely on color as the main ingredient of their creations. If something isn't working they immediately add more color somewhere when usually a simple shift in light and dark will make a world of difference. When I first started showing my work professionally, someone gave me some valuable advice. He said to look at a painting by squinting at it and analyzing its use of light and dark. Many new painters tend to paint with all midtones, avoiding lightest lights and especially darkest darks. It is the strength of these tones that carry your artwork. Be brave and be confident but exercise restraint.

# Supplies

At some point in your artistic journey you may find that you naturally gravitate towards certain art materials and away from others. While it's exciting to experiment with new supplies, proficiency comes from finding your favorites and really exploring all of the possibilities that they offer. Bouncing around from one fad to another can throw you off course and slow you down in the long run. By working with a specific selection of materials and supplies, you become intimately familiar with them. Then when it comes time to create your artwork, you spend less time consciously thinking about your materials and free up your creative thinking. By using them exclusively you are so comfortable that the materials are simply an extension of your mind. You can switch over to unconscious creation and make art intuitively.

Here are a few of the items I use on almost every piece of art. Grease pencils, also known as china markers, are great for drawing compositions in the initial stage as well as drawing on top of the paint for a gestured line or a small detail. They make a nice heavy line similar to a thick pencil but have more staying power and don't rub off as easily as graphite.

Unlike watercolor painting, in which I firmly believe you need to buy the best quality brush that you can afford, acrylic is much more forgiving. My personal preferences for brushes are long-handled flats and filberts. The filbert is similar to a flat but with a rounded corner of somewhat shorter bristles.

As for brands of paint, I gravitate towards heavy body acrylics for their ability to layer up thickly. If I want something with more flow off the brush, I simply mix it with more water. You get what you pay for with paint, so be mindful when purchasing inexpensive student-grade brands. They tend to lack coverage.

And what about substrates or painting surfaces? Stretched canvas is easy and readily available, and if you watch for sales you never need to pay more than 50 percent of retail. Wood panels and Masonite panels are also a personal favorite when I want a unique size or shape.

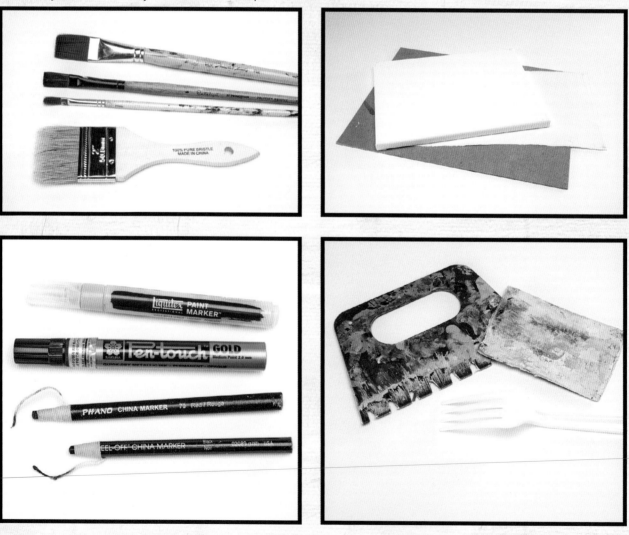

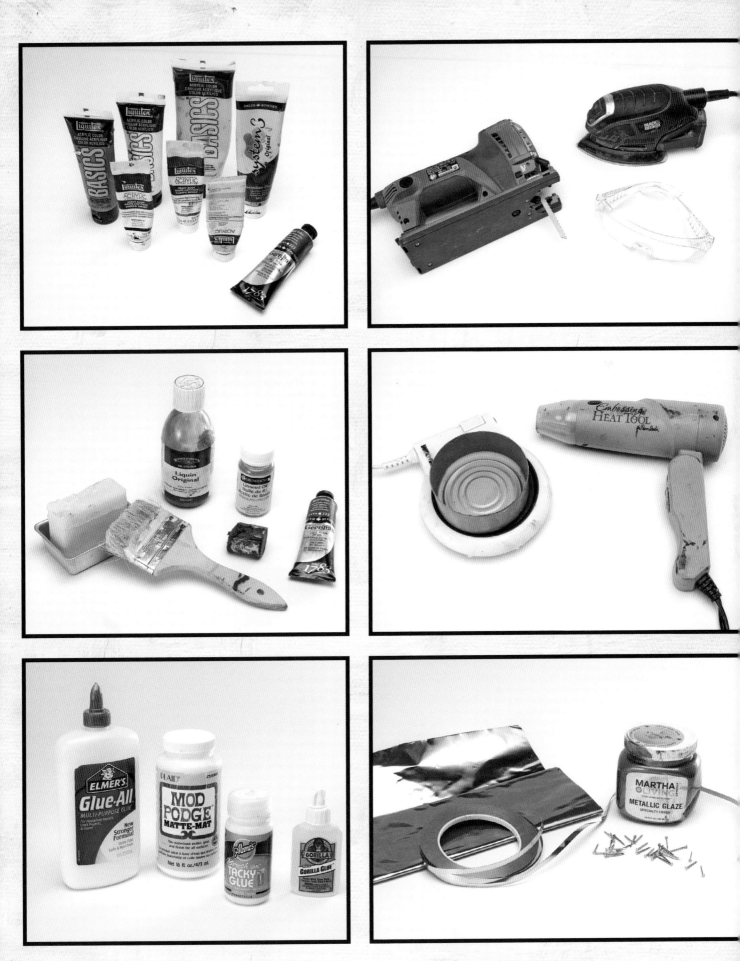

# Color

Color in your artwork is a very personal journey. My own taste in color changes with every collection of artwork I view. In my own work I lean towards less is more. Because my ultimate goal is to allow my paintings to evolve, that frees up my brain to work with a limited color palette. When I'm in the zone and working without thinking, I don't want to stop to think too much about what color to use where. Limiting color choices also helps with overall balance in your work. If you mix a few basic hues, color harmony will come naturally.

It is far more valuable to view your paintings in terms of value (light and dark) rather than color. Avoid using too much midtone in your paintings and be sure to include lightest lights and darkest darks. It takes a lot of confidence to amp up the volume in this way, but your paintings will thank you and so will the people who see them. The viewer's eye needs these extremes in value to follow around the composition and keep it interesting. Take a ho-hum painting that is sitting so demurely in your studio and change an area of midtone to dark and another area of midtone to light. See if that doesn't shake things up a bit!

Yellow Ochre     Cadmium Red Medium     Ivory Black     Cerulean Blue     Vermilion

## Anders Zorn's Colors

Anders Zorn is known for his use of a limited color palette: Yellow Ochre, Cadmium Red Medium, Ivory Black and White. (There is some debate as to his use of Cerulean Blue and Vermilion.) These basic five colors are earthy versions of the standard mixing colors and are especially useful for portraiture and figurative work.

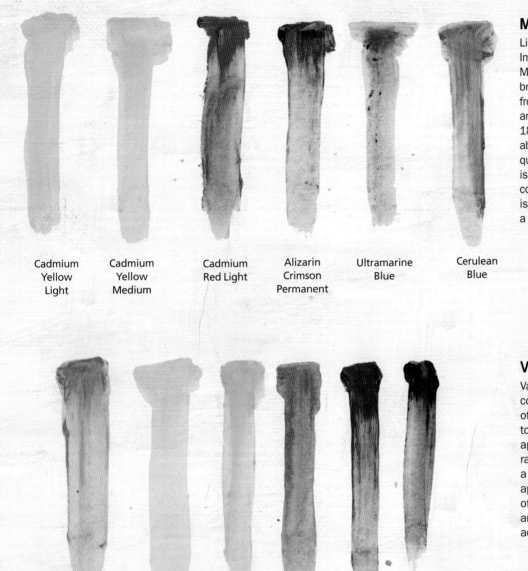

## Monet's Colors

Like most of the Impressionists of the era, Monet preferred to use pure bright colors and shied away from browns, earth colors and eventually black after 1886. When interviewed about his choices, he was quoted as saying, "The point is to know how to use the colors, the choice of which is, when all's said and done, a matter of habit."

Cadmium Yellow Light

Cadmium Yellow Medium

Cadmium Red Light

Alizarin Crimson Permanent

Ultramarine Blue

Cerulean Blue

## Van Gogh's Colors

Van Gogh's use of exuberant color changed the direction of art. He didn't strive to recreate color as it appeared realistically but rather he tried to capture a mood or emotion. His application of color was often bright and even garish, and his choices varied according to mood.

Yellow Ochre

Chrome Yellow

Cadmium Yellow

Chrome Orange

Vermilion

Prussian Blue

Ultramarine Blue

Emerald Green

Red Lake

Raw Sienna

Black

# Why Red?

Red has long been used by most cultures to represent everything from power to divinity to good luck. Slavic textiles incorporate red embroidery to protect the individual wearer and the home from illness and evil spirits. Indian brides wear red saris to show happiness and Madame de Pompadour decorated her chateaus with the color red for the feelings of coziness and comfort it evokes. Personally I love the jolt of energy that red brings to a room or an outfit.

For me, red lines in the middle layers of my paintings represent the lifeblood of my ancestors and have an emotional attachment as well as aesthetic. The lines form designs and symbols and create a safety net of sorts in that I don't think too much about their placement or how/what I am drawing. This automatic act takes a bit of the pressure off while I'm creating. The lines are always there in my paintings whether or not they are visible in the final layer. They are my life's journey, hidden in every canvas.

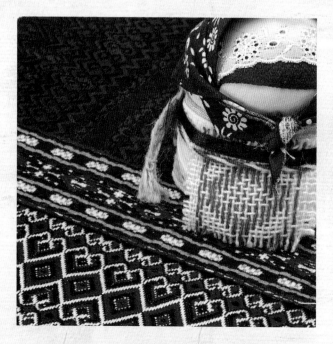

# Texture

Just like building a house, you can not underestimate the benefit of a solid foundation on which to produce your painting. While considering a substrate on which to work, don't overlook unusual surfaces such as paper bags, cardboard, wood, canvas nailed to plywood or wood collaged with papers. I could go on for ages.

For larger studio work, stretched canvas is an obvious choice because it's lightweight and easy to hang. When working smaller than 24" × 24" (61cm × 61cm), personally I like wood because of the irregularities in surface texture. Two different products. Two different outcomes. Each one beautiful and unique in its own right. You can alter the surface of both to simulate the other. I know, confusing right? Just experiment and have fun. Remember, a little bit of research and prep work in the beginning will allow you to be that much more intuitive during the painting process and that's what we are after—a loose, confident painting that just flows out of you instinctively.

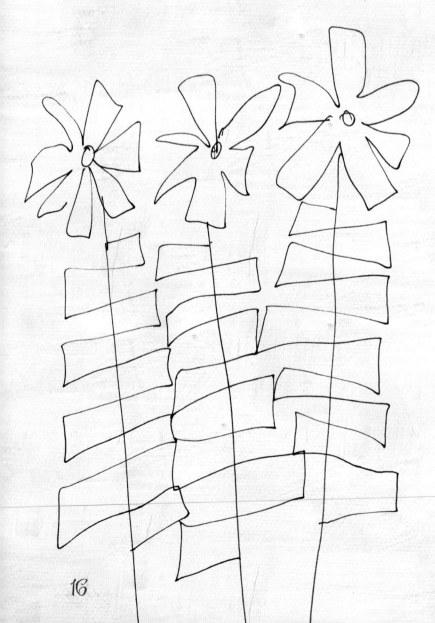

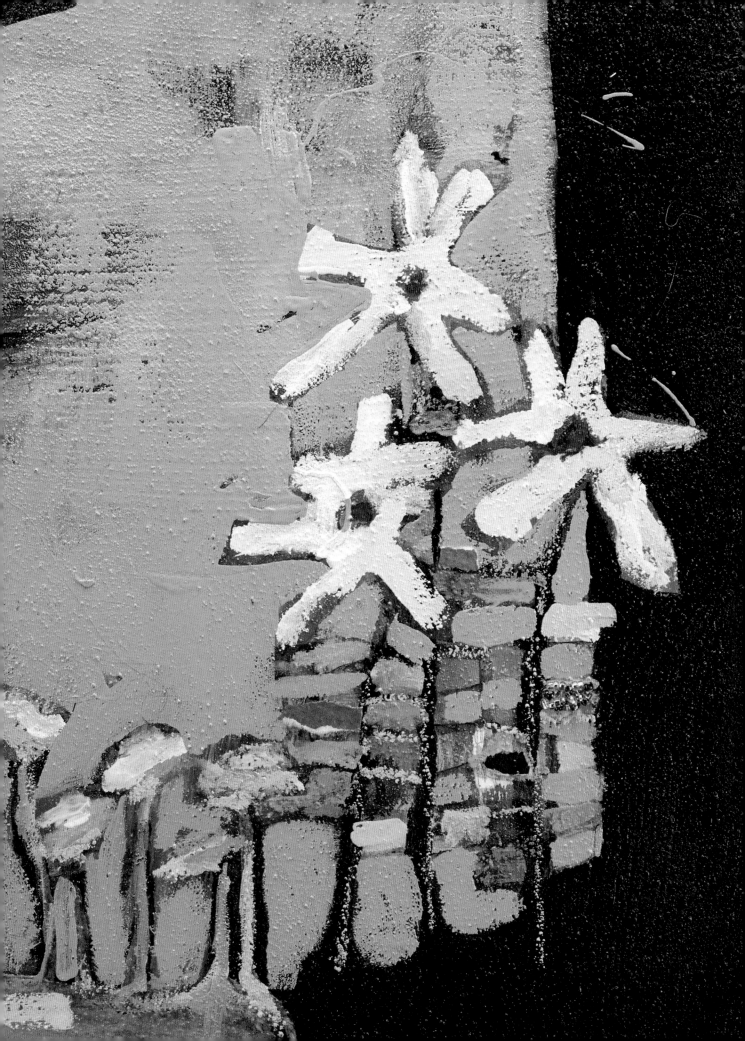

## Gesso

Most stretched canvases you purchase will be primed with gesso already, so you usually don't need to worry too much about this step. It becomes important when you are painting on unfinished wood, Masonite or other surfaces. Gesso creates a barrier between your paint and any resins or sap that may rise to the surface of the wood. These natural materials can create stains underneath your painting and become quite unsightly down the road. The last thing you want is to complete a beautiful portrait and to have a dark, irregular blotch show up on the forehead of your muse. In addition, when working on a slick surface such as Masonite, the gesso works to adhere paint to your substrate. It adds "tooth" and gives the paint something to grab on to so that it stays in place.

You can also add a small amount of pigment to your gesso to create an undertone to the final painting. Soft red will make your painting appear warm and cozy while a cool blue will create a cooler ethereal effect.

## Texture Gel

This is one of my all-time favorite products. It dries rough and textured. You can spread it on thick or thin. Just don't use your hands as it contains tiny fibers that can irritate your skin. Scoop it out with a plastic spoon or fork and spread it across the canvas. I usually apply texture gel in patches around the canvas. Let it dry before proceeding.

## Sgraffito

Any time you apply paint or gesso thickly, it's an opportunity to scratch through the surface and create designs. I tend to make up-and-down and side-to-side motions to create my marks, somewhat reminiscent of woven textiles. Everyone has their own inherent mark-making signatures, so try it without too much thinking and see what comes naturally to you. Plastic forks, scrapers and other tools are great for making marks. Plastic hotel room keys or old credit cards can be notched along one edge and used to scrape through the wet surface.

## Texture

There are so many products on the market that simulate everything from glass beads to coarse sand and everything in between. Or why not mix gesso and a little red clay from your backyard? This will not only add grit to the surface but also give it a warm glow. Or how about mixing in a little lint from your dryer? Thanks to all of the great adhesives on the market you can glue down just about anything. The key is to match the surface on which you paint to the product you are using for texture. For instance, if you are adding a rigid product that can crack or flake off, be sure to work on a rigid panel such as wood or Masonite. If you have a flexible acrylic product, you can use those on canvas.

## Cardboard

If you would like to really add some thick depth to your surface, you can glue down scraps of cardboard. If you have corrugated cardboard you can remove one side and expose the repetitive ridges between the layers. This can make a nice pattern under your paintings.

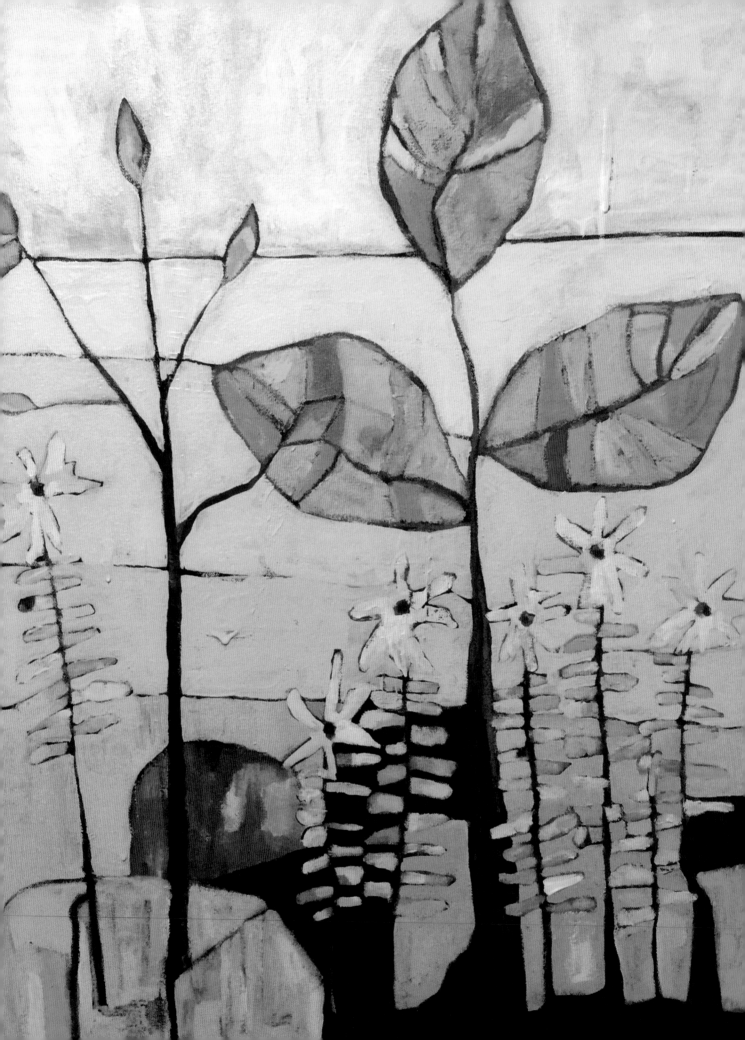

# CHAPTER 2
## Utterances

I don't know about you but a glaring white canvas is intimidating to me, standing there on the easel, shining in all of its cleanliness. On some level it's already beautiful in its pristine condition and who am I to mar it? I credit a particular kindergarten painting student with this solution—just attack it. Revert to the freedom of childhood painting without expectation or outcome and cover up all of that white with random color. This is a good time to use up odd bits of paint from your palette and random tubes of color bought on a whim while cruising the aisles of art and hobby supply stores. Am I the only one who has a basket of crazy paint colors sitting in the corner of my workroom? Tinting your canvas serves another purpose than just loosening up and getting in painting mode. First it eliminates that distracting white of the canvas grinning through subsequent layers as the painting progresses. More importantly, the subtle color shifts underneath the layers of painting give depth and sophistication to the final piece, and tinting the canvas in one color family can really unify a composition. I find that using seemingly random and loose areas of color can actually inspire the shapes and placement of objects in a piece. It's the first step towards allowing your paintings to evolve organically. Let's take a look at my two favorite methods.

# Cast of Characters

## A Peek Inside My Drawing Alphabet

### RABBITS

An abundance of rabbits with large white tails live in the woods around my home. One of them is quite tame and hops alongside our truck many mornings as my husband heads up the driveway on his way to the office. I read somewhere that rabbits are associated with family and harmony, and I like that they hang around our home that we are making for our blended family.

### FLOWERS

I just love them. Mostly I love wildflowers that take up residence in the yard and grow wherever nature put them with very little help from yours truly. This year my son discovered the most beautiful blue irises growing in the woods at the edge of the water, just hanging out in the shade with their feet wet like they hadn't a care in the world. They are the most intense shade of blue that it's hard to imagine that they didn't come out of some garden catalog or high-end nursery.

What are some features of the landscape where you live? Do you have a special place where you go to relax or commune with nature? Next time you find yourself in a location that speaks to you on a deeper level, grab your sketchbook and record your impressions.

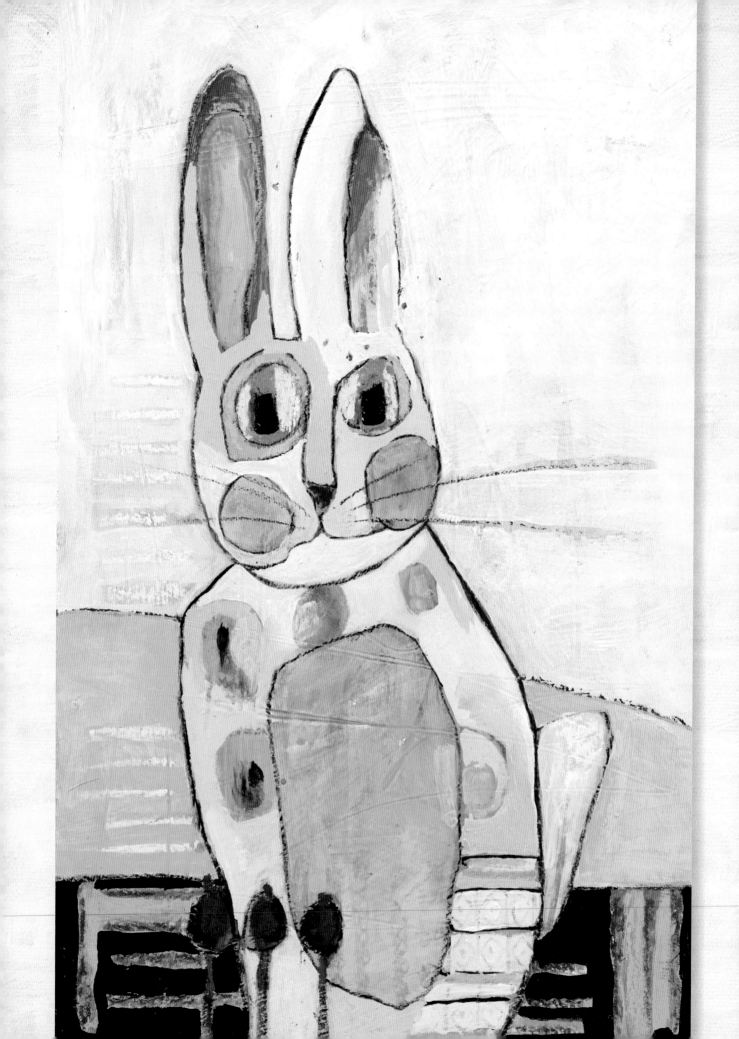

# White Self Rabbit

Here is the most basic painting technique I use when I want to work intuitively but don't really have an idea of where I'm going. I've got that urge to create but no direction. It's also a great exercise when suffering from artist's block as there is no prescribed outcome, so there's nothing to make you insecure. Rather, you are responding to the marks made initially and making new ones accordingly. When I work this way I build up patterns by stamping or scraping into the paint. Then I sit back and interpret the surface, looking for what I refer to as the "spirit" of the painting to come through and tell me what it wants to be.

## GRAB IT!

acrylic paints in a variety of colors

assorted brushes for painting

cardboard scrap for stamping

gesso

grease pencil

large brush for gesso

old rag for wiping hands and brushes

paint palette

pastels

substrate on which to paint. I am using a 10" × 16" (25cm × 41cm) Masonite hardboard panel cut with a circular saw

water for rinsing brushes

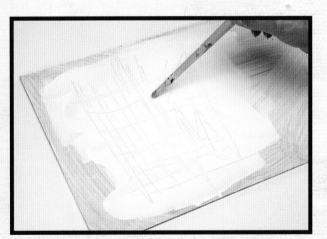

### 1 Prep the Surface
Using a wide brush, add a layer of gesso to prime your surface. In this example I am working on a Masonite panel. I applied it quite thick and made several random scratches into the surface. Allow to dry completely before proceeding.

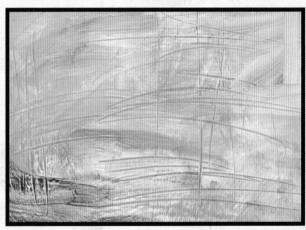

### 2 Add Color
Using a variety of colors, loosely cover your entire painting surface. Keeping the color wet and juicy allows for spontaneous color mixing. You can use your fingers or a wide brush to apply paint.

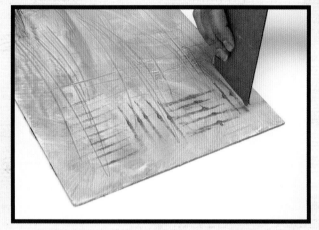

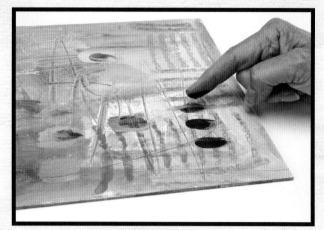

## 3 Start Stamping

Cardboard shapes dipped into paint create more geometric and linear mark making while your hands and fingers will make more organic shapes. Combining both on one piece of art creates interest and variety.

## 4 Stamp with Your Fingers

Using your hand and fingers, add random patterns. Try holding your hand in a variety of positions. Eventually you will find that certain actions start to come naturally and you will make shapes spontaneously.

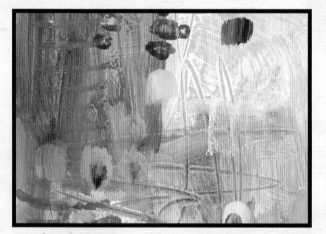

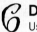

## 5 Finish Stamping

This is when all of your sketching and getting 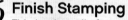 comfortable with your personal imagery shows itself. Prop your piece up against a wall or on your easel and look at it to see what shapes or images pop out at you. Turn your piece onto its side and repeat. Repeat until you've considered all four directions. Eventually an image will present itself and become obvious no matter which direction you turn your piece.

## 6 Draw the Rabbit

Using a grease pencil, draw in the shapes of your image. I try to use the natural breaks in color as a line as much as possible. This makes for some interesting shapes and proportions that are far more interesting than anything I can plan and often creates a more quirky expression when creating faces.

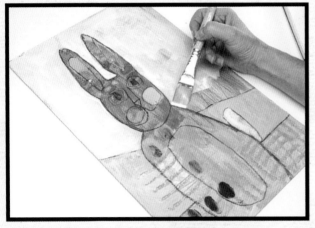

## 7 Paint the Background

Paint your image. Try incorporating the patterns and lines created in the earlier steps as a part of the painting. In this example I kept the fingerprints as spots on the rabbit but made a few color adjustments. I also maintained the stamped cardboard lines in the background but again changed the color to incorporate them into the background.

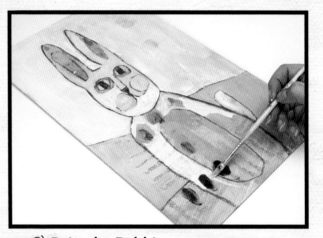

## 8 Paint the Rabbit

Using acrylic, paint the bunny. Try to incorporate the patterns and lines you created before.

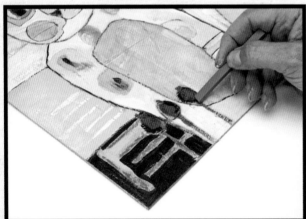

## 9 Final Details

With the pastels add details. Give him whiskers and color in the flowers. Add any other texture and color you want.

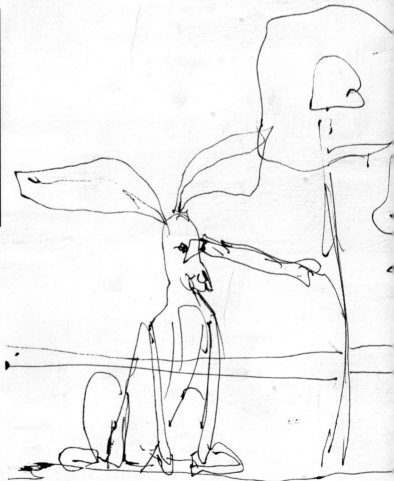

# Additional Stamping Ideas

I'll never forget my first class on my first day of college, Intro to Design. The instructor had us use enormous sheets of kraft paper, black paint and only our hands to create a series of designs and allover compositions. It was then I discovered that interesting shapes are only as far as the end of your arm. And if we're being honest, there is something quite freeing about getting one's hands dirty with squishy paint and just playing like we did as children. If you ever feel intimidated by a canvas or need an extra push to start a new project, just dip those hands and fingers into the paint and mush it around on the canvas, then play around with stamping shapes. Before you know it you will be lost in the process and surprised at the interesting designs you've created!

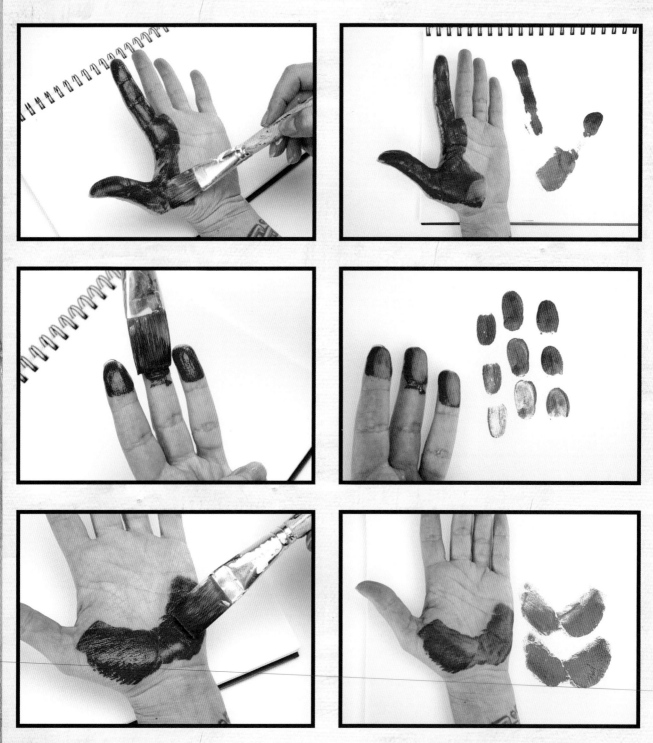

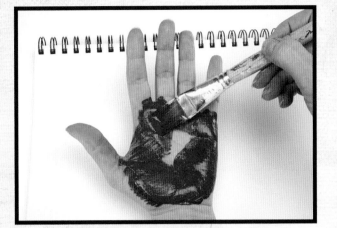

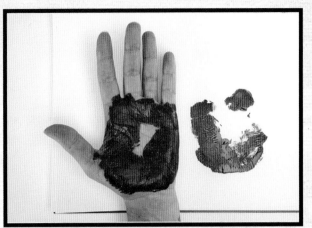

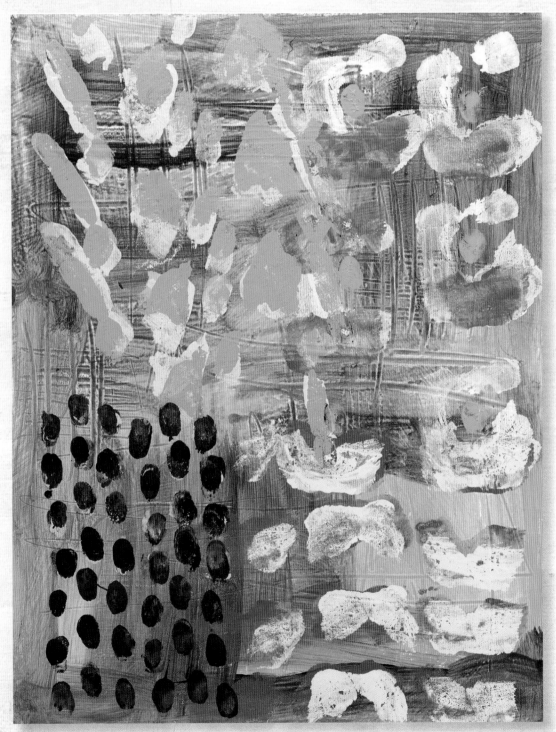

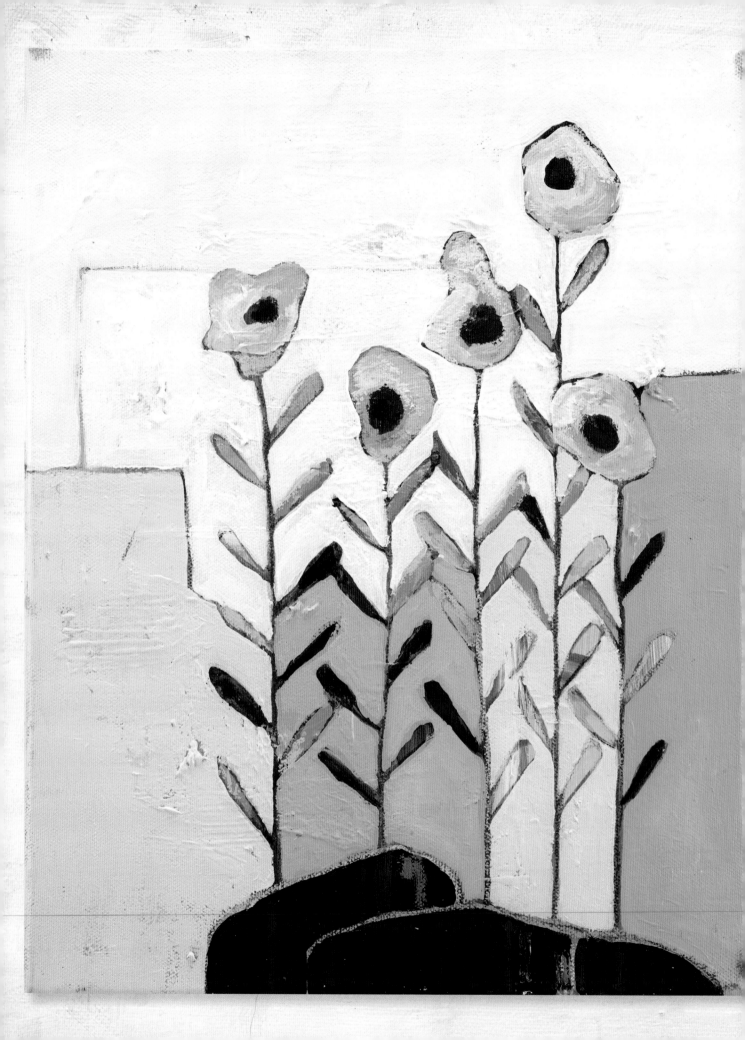

# Chaucer's Eye of the Day

After years of prepping my canvases using nothing but seemingly random patches of color, I recently started to approach the underpaintings more deliberately. Rather than an entire canvas filled with areas of color that move gently from one shade to the next, I find myself painting definitive blocks of color. I still don't labor too much about particular colors or how big or small the blocks should be. I am working intuitively but with a small amount of purpose. I tend to use squares and rectangles because I am so heavily influenced by textile swatches, and in my mind I am creating a patchwork quilt from paint. You could easily use circles, triangles or any other shapes that are pleasing to your eye. Then try using the lines created by the breaks in color as a way of breaking up the background. Those underneath shapes can also dictate object placement. In this particular floral piece, you can see how a series of vertical rectangles transforms into individual flowers while an otherwise plain background is transformed to create depth by using two different shades of blue over the top of the rectangles and squares underneath.

## GRAB IT!

11" × 14" (28cm × 36cm) stretched canvas

acrylic paints in a variety of colors

assorted brushes for painting

grease pencil

old rag for wiping hands and brushes

paint palette

paper texture paste

pastels

plastic fork or similar

water for rinsing brushes

### 1 Create Texture

Using a plastic fork, scoop out a small amount of paper paste and spread unevenly on the canvas. Be careful not to build up too much thickness. It should be equivalent to a piece of watercolor paper attached to the canvas in a random manner. Allow to dry thoroughly.

If you don't want to wait for the paste to dry, use a craft dryer to speed up the process.

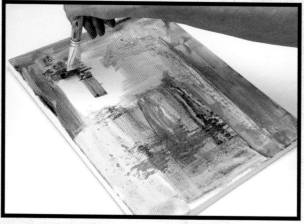

### 2 Add Color

Use your 2" (51mm) wide brush and loose wet acrylic color to cover the canvas with patches of color. Don't worry about keeping clean straight edges between colors. Just work your way around the canvas and pick up the texture using large blocks of color. Let dry.

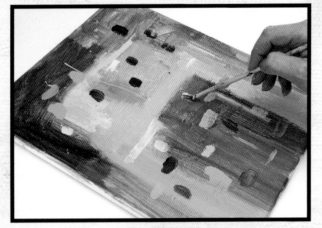

## 3 Paint Small Patches

Now use a smaller brush, between ½" to 1" (13mm–25mm), to paint small patches of color all over the surface. Just dab the colors without too much thought.

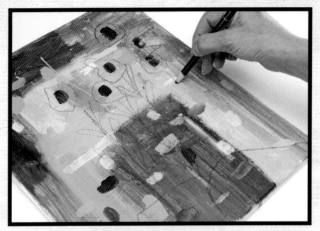

## 4 Draw the Flowers

Using a grease pencil, sketch flower shapes using the small patches of color as the centers of the flowers.

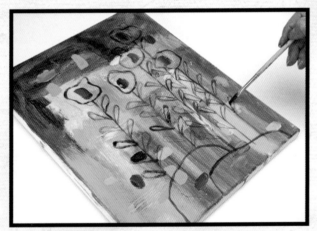

## 5 Paint the Flower Outlines

Go over your pencil lines with paint, further defining the shapes of the flowers.

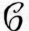

## 6 Start Painting the Background

With varying shades of blue, paint the background around the flowers. You can break up the background into different shapes to add visual interest, similar to a patchwork quilt. Paint around the petals, leaving some of the colors you created already visible inside the leaves.

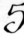

## 7 Finish Painting the Background

Continue painting around the flowers, developing the patchwork background.

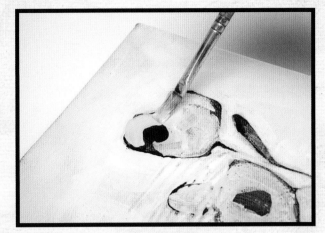

## 8 Paint Flower Details

Paint the yellow petals of the flowers, working around the colored center of the flowers.

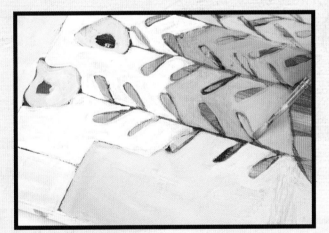

## 9 Finish Painting the Flowers

Paint a little inside the leaves if they look murky or the background colors don't fill them the way you want. You want to differentiate the leaves from the background. So if the colors aren't popping, just cover them and add new shades. Add a little red so the leaves aren't too uniform.

## 10 Final Details

Fill in the rocks, then use pastels to add strokes of color and texture.

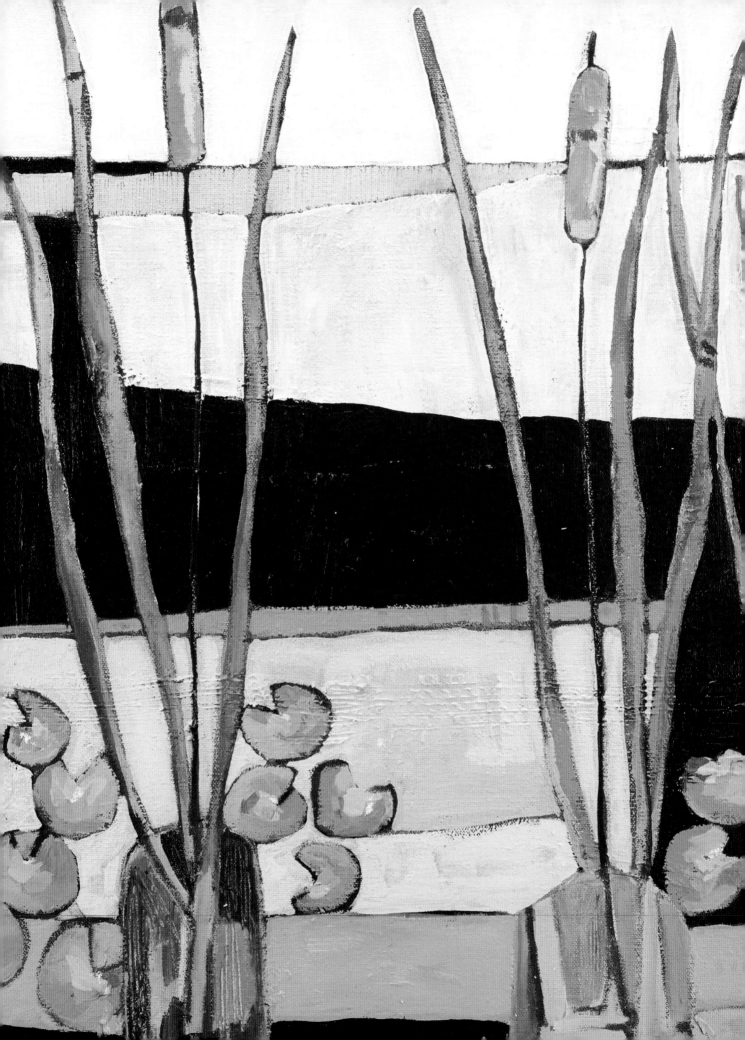

# CHAPTER 3

## *Phrases*

Have you ever noticed how landscape compositions can be simplified down to simple stripes? Maybe it was the years spent designing textile fabrics, or maybe it's just a part of my inherent personality, but I love the regularity of stripes and plaids, and I seem to take notice of these regular patterns everywhere including landscapes. It makes no difference whether it's horizontal lines of clapboard siding on a cottage or the linear sections of plant life and water repeating themselves across a landscape. They all draw me in equally.

Just like those flowers and weeds that pop up at random at the edge of the pond, I prefer to allow compositional elements in the artwork to announce where they wish to be located rather than try to force them unnaturally. I happened upon this next technique rather by accident after drawing lines on a work in progress using red paint that was too wet and then setting the canvas aside to dry. The lines ended at different stages along the way because of the texture I'd applied earlier.

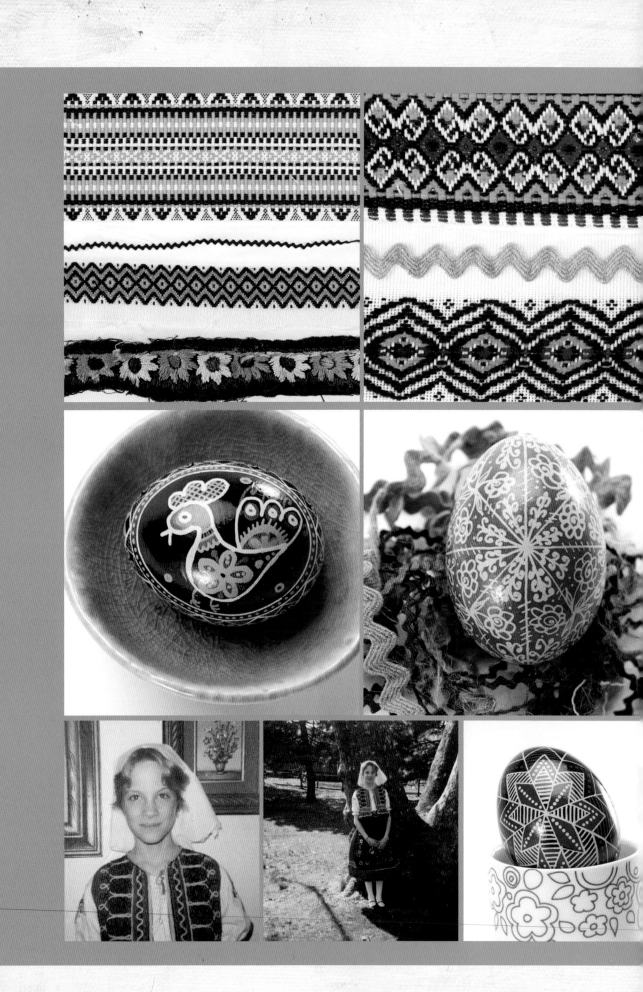

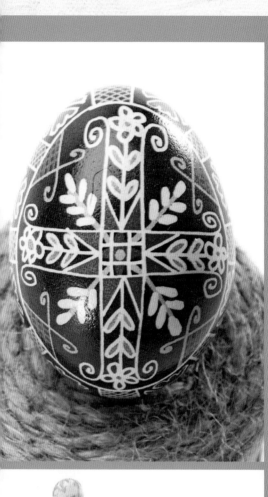

# Cast of Characters

## A Peek Inside My Drawing Alphabet

### PYSANKY

When I was eleven, I appeared on a television special about writing on pysanky eggs. I come from Eastern European descent and part of my contribution to the video was to wear a traditional Slavic dance costume of a white folk blouse, patterned vest, embroidered skirt and black apron. While appearing on television may have been exciting to a young girl, it was the traditional Eastern European folk costumes that captured my heart. I've been collecting bits and pieces of Slavic costumes and textiles ever since. The bold stripes of handwoven apron fabric in contrast with the delicate embroidery of Hungarian trim pieces make my heart beat just a little bit faster.

Think about your cultural heritage. Is there a folk art element associated with your ancestors? Embrace your familial history and think of ways to incorporate it to give your artwork a sense of timelessness.

# Preparing Red Paint

As mentioned earlier, this technique came about purely by mistake. I was drawing red designs onto a canvas using a squeeze bottle and my paint was too wet. It immediately started to run. The lines ended at various stages along the way because of the texture applied earlier. After it was dry I turned it upside down and the red lines appeared to be growing up from the bottom. They had a pleasing, somewhat scattered effect both in height and spacing and appeared much more natural than if I had placed them intentionally. I now use this technique whenever I want to divide a composition into repetitive stripes and/or linear sections.

## GRAB IT!

red acrylic paint or color of your choice

sketch paper

squeeze bottles

water

### 1 Gather Materials

Get your red paint and a few squeeze bottles in varying sizes. Think about how much paint you'll want for your project. Do you only need a small amount? If you want thinner paint lines you can use a bottle with a smaller nozzle.

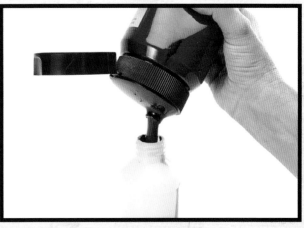

### 2 Fill with Paint

Unscrew the lid of the squeeze bottle. Then fill the squeeze bottle halfway with red paint or a color of your choosing.

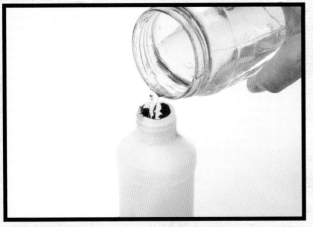

## 3 Add Water

Pour water into the squeeze bottle to create a 2:1 ratio of paint to water.

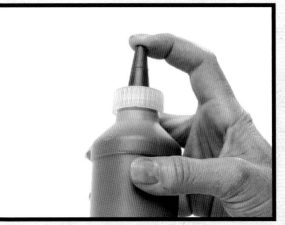

## 4 Mix the Paint

Put the lid back on and place your finger over the opening at the top. Then shake the bottle to mix the paint and water.

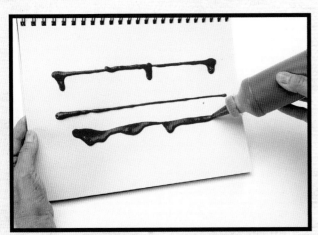

## 5 Test the Paint

Test the thickness of the paint. It should be like thick cream, thin enough to drip but not so thin that it runs off the edge. If it comes out too thick, add more water. Only add a little water at a time though. You don't want the mixture to get too thin and runny. It may take a little experimenting to get the right ratio for your particular paint.

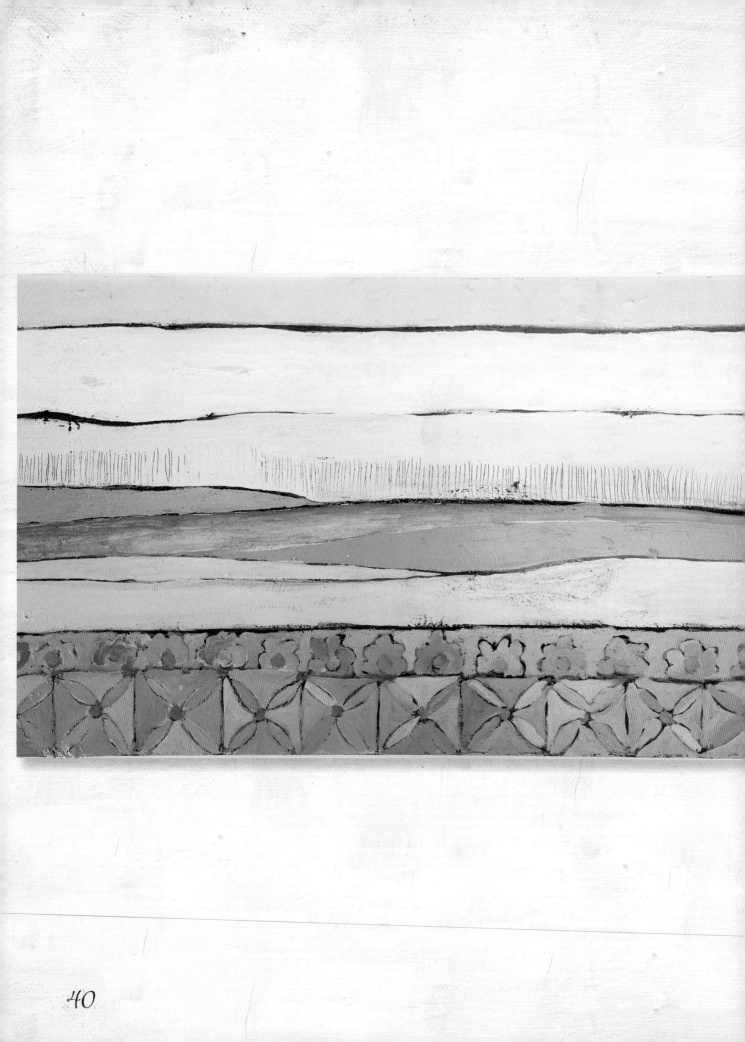

# Millpond

Drip some loose red paint all of the way from the top of your canvas to the bottom, and you've got the perfect underpainting on which to create a simple abstract landscape. Reducing landscape paintings down to a series of stripes allows for abstraction and experimenting with pattern. A few simple rules regarding color placement will allow you to paint freely while stacking up stripes and layers: Keeping color and pattern more intense and crisp towards the bottom of the canvas and getting softer and lighter as it moves up will help to create the illusion of depth. Punctuating the middle ground with a darker neutral color will reinforce this idea. Rather than painting obvious flowers in the foreground, consider using a floral pattern as a means of abstraction. Stripes can become a playful replacement for trees in the distance.

## GRAB IT!

acrylic paints in a variety of colors

assorted brushes for painting

gesso

large brush for gesso

liquid red paint

old newspaper

oil pastels

paint palette

paper texture paste

plastic bottle with squeeze top containing liquid paint

plastic fork or similar

substrate on which to paint. (I used a 10" × 16" (25cm × 41cm) Masonite hardboard panel.)

water for rinsing brushes

## 1 Create Texture
Using a fork, scoop out a small amount of texture paste and apply it to the Masonite using horizontal movements. About 1 tablespoon (15ml) of paste will be plenty for this size surface. Allow the paste to dry completely.

## 2 Add Gesso
When the paste is dry, use a wide brush to cover the entire surface with gesso. Let dry.

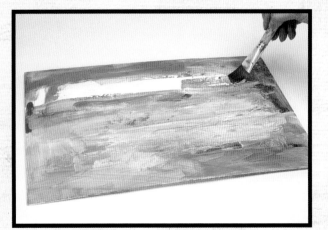

## 3 Add Color

Paint patches of acrylic color over the white surface. Keeping the sections horizontal will reinforce the perception of a landscape and can help with composition in future steps.

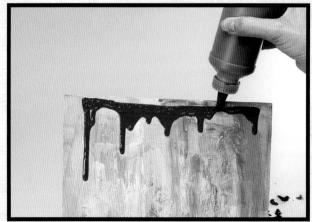

## 4 Drip Paint

Turn your canvas on its side and prop it against the wall or a chair leg or other surface. Place newspaper underneath to protect your floor or table. Drag the bottle across the top edge of the board, squeezing gently at the same time.

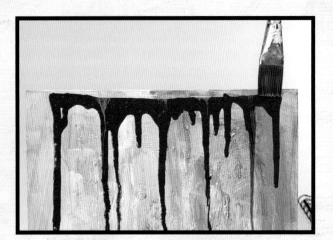

## 5 Add Water to Help the Drips

Let gravity pull the paint down. If the paint isn't dripping down enough, take your brush and add some water to help push the paint down the board. The texture you painted earlier forces the paint to shift and move around instead of being a perfectly straight line. Let dry.

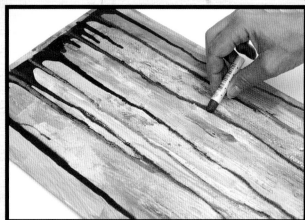

## 6 Define the Lines

Go over the paint lines with oil pastels to better define them and bring in new colors. Use your finger to rub the oil pastel in and blend.

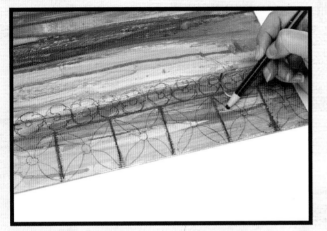
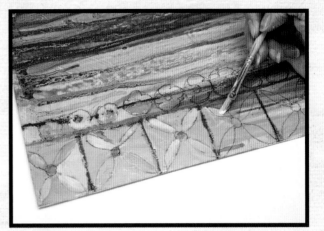

## ⁷ Draw Patterns

Draw repetitive patterns onto the larger areas at the bottom of the painting. You can use an oil pastel, grease pencil or a regular pencil for the drawing.

## ⁸ Start Painting

Fill in the patterns you just drew with acrylic and a small brush. You can go back over the shapes again to redefine them if you paint over the drawn lines.

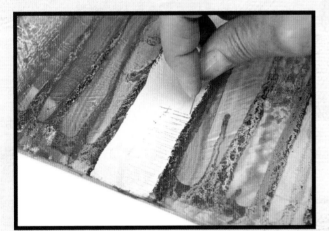
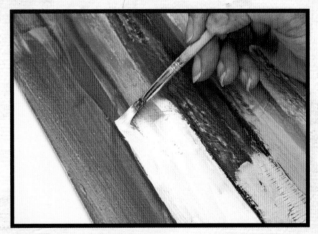

## ⁹ Add Texture Marks

Fill in the striped sections with a variety of colors, keeping the color darker towards the bottom and lighter towards the top. As you're painting, use a straight pin or pushpin to make texture marks in the paint while it's still wet. These little lines can imply trees in the distance at the horizon line.

## ¹⁰ Continue Painting

Continue working your way around the piece, filling in the rest of the stripes and flowers with paint. As you paint, work up to the pastel lines, but not over them.

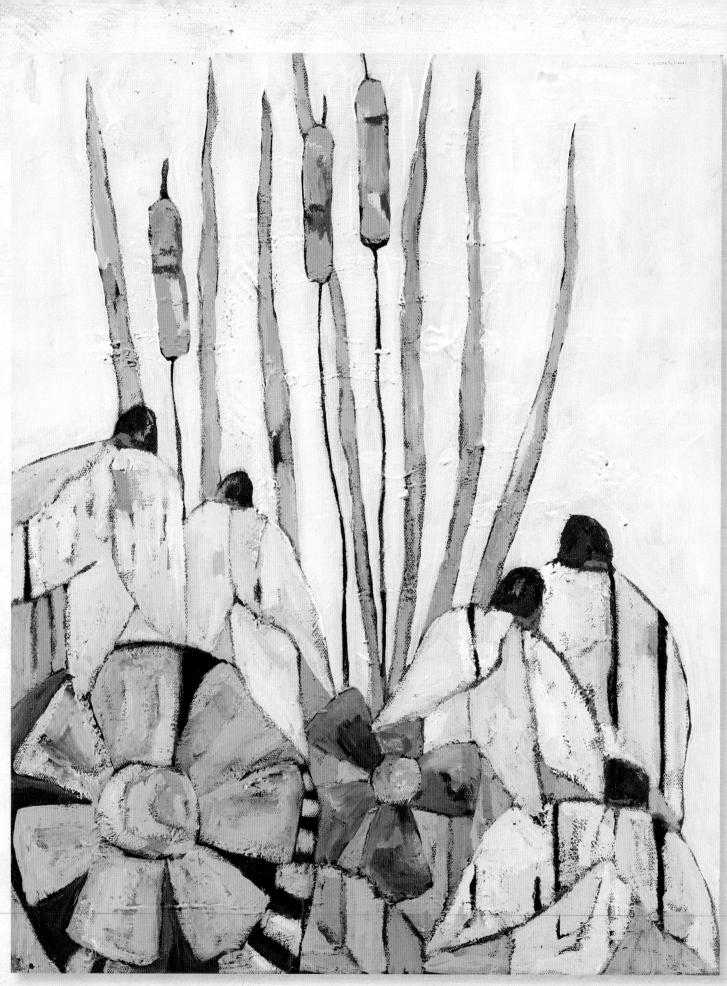

44

# Mr. P's Garden

Wildflowers such as coneflowers and cattails have the glorious habit of arranging themselves in pleasing clumps without the gardener's interference. By using the drip method to add long stems to your floral compositions, you too can achieve this natural rhythm. Long drips lend themselves to taller flowers, shorter drips to lower clumps and ground cover.

## GRAB IT!

16" × 20" (41cm × 51cm) stretched canvas

acrylic paints in a variety of colors

assorted brushes for painting

oil pastels

paint palette

paper texture paste

plastic bottle with squeeze top containing liquid paint

plastic fork or similar

water for rinsing brushes

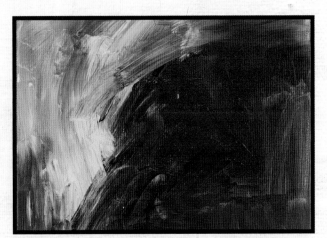

### 1 Prepare the Background
Spread texture paste across a few areas of your canvas. Be careful not to get it too thick. Let it dry. Then paint over the texture and cover the canvas using primary acrylic colors. Let the colors mix and blend together on the canvas.

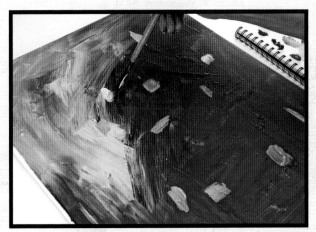

### 2 Add Small Patches
With a wide flat brush and a variety of colors, apply small patches of color all over the canvas like spots. Try to use a combination of lights and darks.

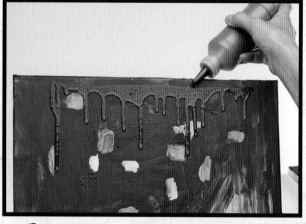

### 3 Add Paint Drips

Use your bottle of watered-down paint and drag it across the top edge of the board, squeezing gently to coax out the paint. Watch the paint as it drips down the canvas. When it gets between halfway and two-thirds of the way down, turn the canvas right side up to stop the dripping process. Let dry.

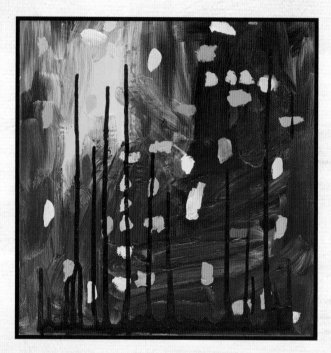

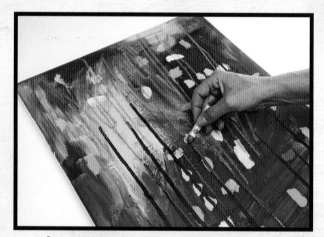

### 4 Draw the Reeds

Study the interactions of the blobs of color and the height of the paint drips. Which ones look like tall reeds and stems? Use an oil pastel to sketch those shapes around the paint drips.

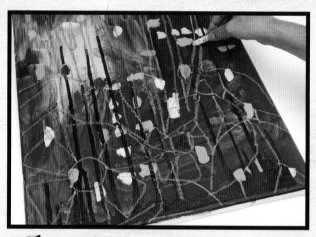

### 5 Draw the Flowers

Look at the blobs of color again. Which ones look like flowers growing up out of the bottom? Using an oil pastel or a thin brush loaded with contrasting colors, sketch in your flowers.

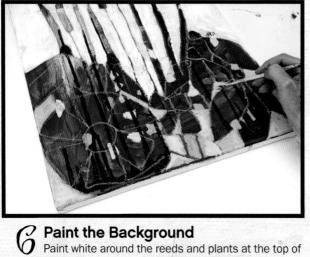

## 6 Paint the Background

Paint white around the reeds and plants at the top of the canvas. For the stems of the flowers and reeds, paint up to the drawn line, not over it. This helps to pop out and define the line. You create the shape by painting around the shape.

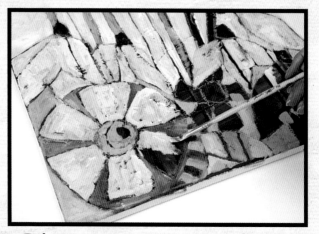

## 7 Paint the Flowers

Complete your painting by filling in the shapes and allowing colors from underneath to become a part of the final piece.

## 8 Final Details

Accent your flowers with pops of bright oil pastel.

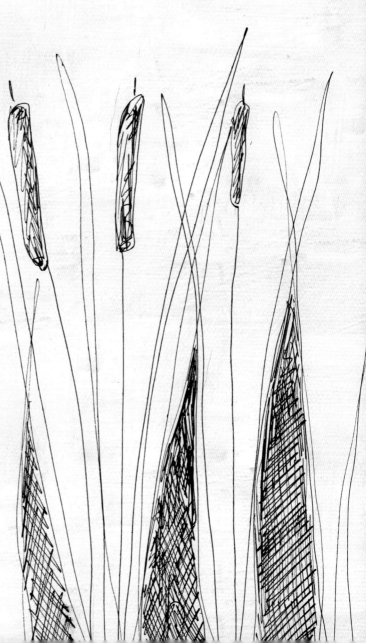

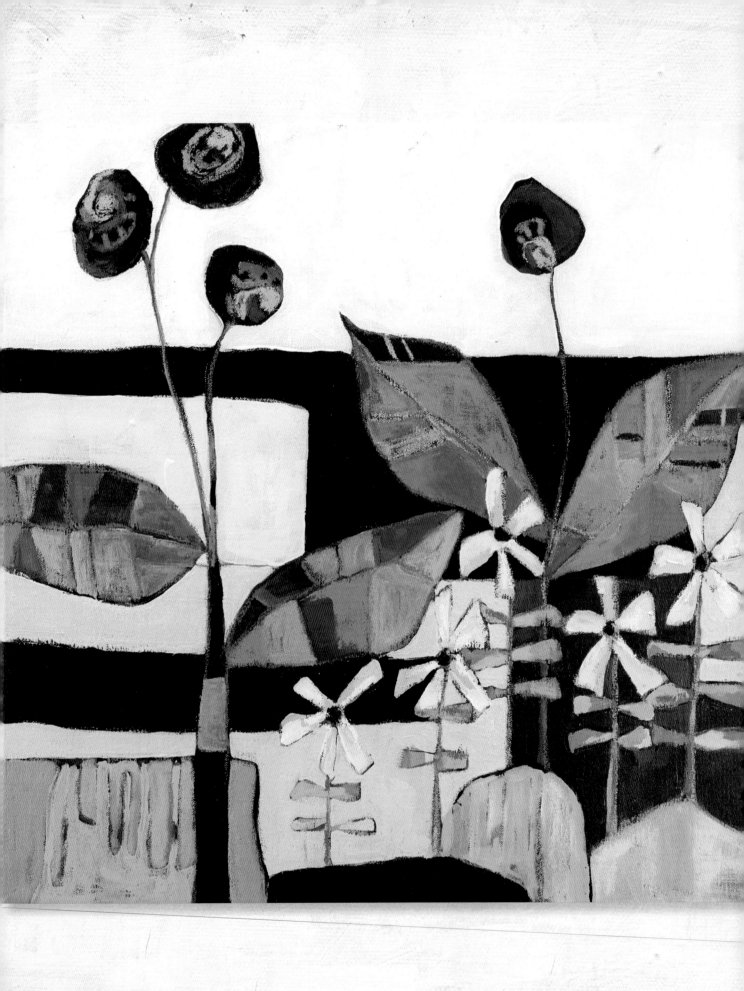

# Red Humbert

Have you ever noticed how the vertical stalks of plants and trees intersecting with the horizontal lines of landscape set up a delicious grid? Take a look next time you are outside in an open area and think about how you can stylize your next painting by setting up a series of intersecting lines. These red cannas are set against a geometric landscape abstracted out by combining drips of red paint in both directions. Horizontal lines become land, water and sky. Vertical lines become stalks for large and small flowers. A small checkerboard denotes tiny leaves on daisies and reinforces the angular theme.

## GRAB IT!

20" × 20" (51cm × 51cm) stretched canvas

acrylic paints in a variety of colors

assorted brushes for painting

oil pastels

old newspaper

paint palette

plastic bottle with squeeze top containing liquid paint

water for rinsing brushes

## 1 Prepare the Background
Without too much conscious thought, paint your canvas using squares and rectangles of color.

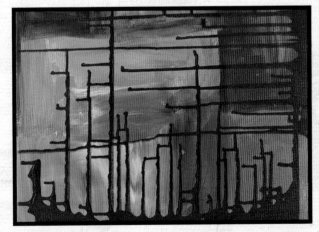

## 2 Drip Paint
Turn your canvas on its side and prop it against the wall or a chair leg. Place newspaper underneath the canvas to protect your floor or table.

Drag the bottle across the top edge of the board, squeezing gently at the same time. Watch the paint as it drips down the canvas. When it gets between halfway and two-thirds of the way down, turn the canvas right side up to stop the dripping process and allow to dry.

Turn the canvas 90 degrees and repeat the dripping. It's okay if the paint from the first pass is still wet and drips. This will add to the effect. Let dry.

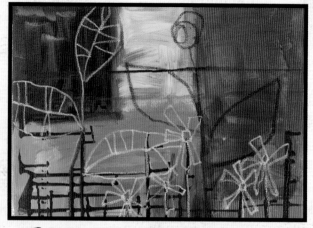

## _3_ Draw the Flowers

Using an oil pastel or a thin brush loaded with colors that contrast with the underpainting, sketch in your flowers. Use the vertical lines to help with placement of flower stems.

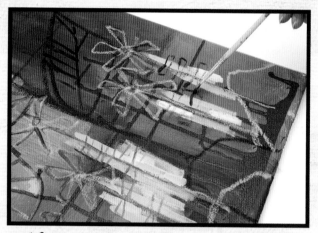

## _4_ Create the Leaves

For the leaves of the flowers paint vertical strokes along the edge of the oil pastel drawing. Use varying shades of green to create a few different strokes. Let dry. Then paint the outline of the leaves along the stems on top of the green colors you just put in.

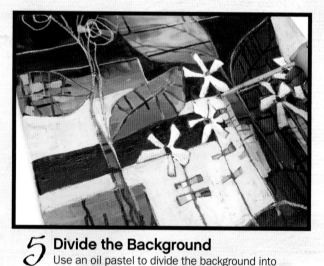

## _5_ Divide the Background

Use an oil pastel to divide the background into sections. Look at the lines the drips of paint created. Draw a few different sections to paint. Then start painting the blocks, painting around the flowers you've drawn.

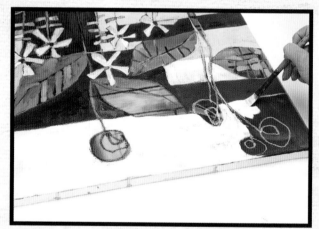

## _6_ Finish Painting the Background

Continue painting the piece and fill in the rest of the background blocks.

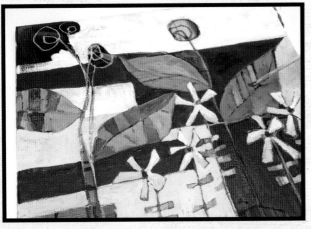

## 7 Paint the Leaves

Follow the guidelines you created before for the leaf shapes and different sections. Don't feel like you're stuck in those lines though. You can change the shapes and colors as you go.

## 8 Paint the Rocks

Fill in the rocks with paint. You can allow the colors from underneath to come through and become a part of the texture and color of the rocks.

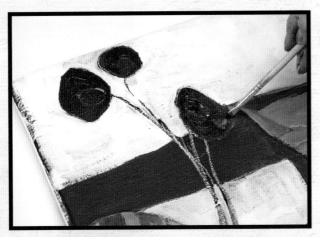

## 9 Paint the Small Flowers

When painting the flowers, be sure to use a variety of tints and shades, rather than all one color of red. You can mix a bit of yellow, white, even green to soften the brightness of the red.

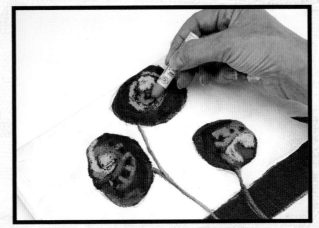
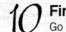

## 10 Final Details

Go back over some of the lines and shapes and better define them with the oil pastel. The oil pastels are great for cleaning up edges and adding some pops of color at the end.

# CHAPTER 4

# Declarations

A short walk through the craft store and you can't help but be inundated with stamps, stencils and repetitive designs on everything from fabric to collage papers and everything in between. If you love pattern and design you're probably not new to incorporating it into your artwork. But what if you're not satisfied with designs born of someone else's creativity? After all, your artwork is your voice. It's your means of communicating what you cannot put into words. Shouldn't it reflect what's deep down inside of *you*? Examining one's ancestral heritage can provide a wealth of inspiration and an endless supply of design inspiration.

There are countless ways that you can incorporate these designs into your paintings. From drawing personal symbols onto your artwork as decoration to creating subtle subliminal imagery within the painting, you can begin to personalize your artworks and tell a story that is completely and uniquely *you*.

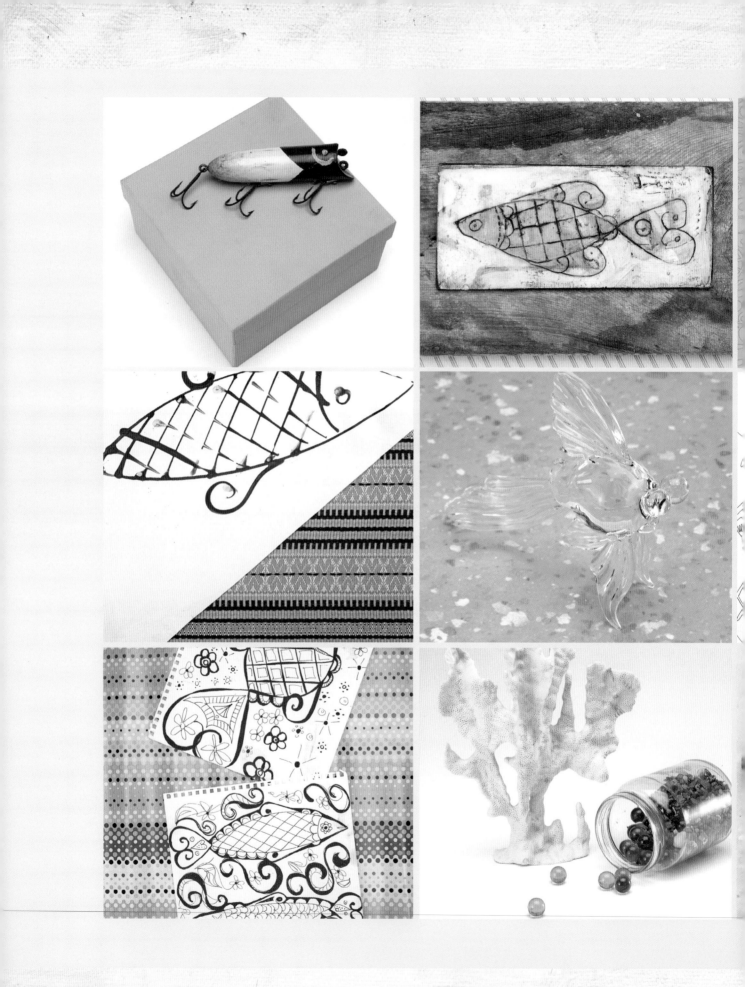

# Cast of Characters

## A Peek Inside My Drawing Alphabet

### FISH

One of my earliest memories of interacting with my father is going fishing. There was a bridge we would frequent to cast our lines. I hated the feel of the roe that we used for bait, and please don't ever ask me to put a wiggling live worm onto that sharp hook! But those moments on Saturday mornings with my dad will stay with me forever. The fish design I use comes directly from pysanky, and for me fish represent flow and experiencing one's life with ease.

Think about a special moment from your childhood and record simple drawings in your sketchbook to denote those memories. Did you share it with a relative? A friend? How can you capture that story in simple drawing symbols to be used in future artworks?

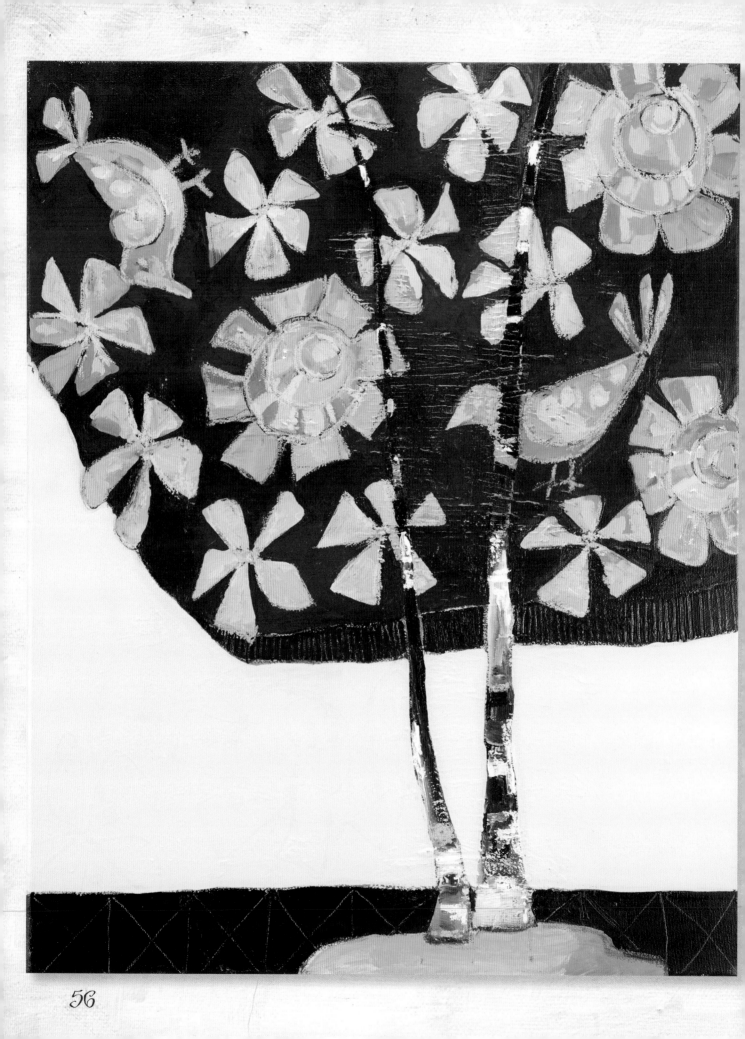

# Water Oak

These fast growing trees with their colorful textured bark and large canopies provide the perfect subject matter on which to play with exaggerated pattern and texture. While I use flowers and birds to add interest to this particular tree canopy, you could eliminate the flowers and use only birds or geometrics, figures of people, animals, etc. I like the lonely horizon at the bottom of this painting and how it balances out the contrasting busyness of the top.

## GRAB IT!

16" × 20" (41cm × 51cm) stretched canvas

acrylic paints in a variety of colors

assorted brushes for painting

oil pastels

paper texture paste

plastic bottle with squeeze top containing liquid paint

plastic fork or similar

paint palette

water for rinsing brushes

### 1 Add Texture and Color
Apply texture paste using an old fork on the general area of the tree trunks. Allow to dry. Then use loose, juicy acrylic paint to cover the canvas with large swatches of color.

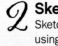

### 2 Sketch the Tree
Sketch in your tree canopy as well as the tree trunks using an oil pastel.

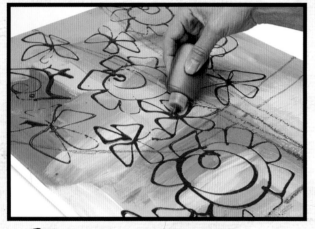

## 3 Draw with a Squeeze Bottle

Use the squeeze bottle of paint and draw designs in the treetop. Keep the scale somewhat large to add to the whimsy of the final painting. Let dry.

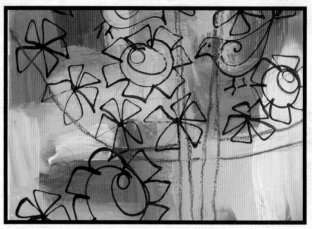

## Controlling the Paint

Use a smaller squeeze bottle when drawing. It's easier to control the paint and get fine lines with a smaller bottle.

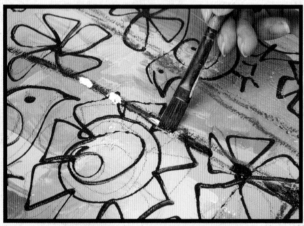

## 4 Start Filling in the Trees

Beginning with the tree trunks, start adding color to the piece. Paint chunks of color on the trunks to create stripes.

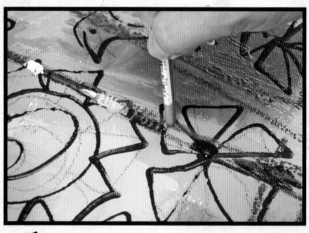

## 5 Add Texture

Use sgraffito (scratching through wet paint) to create a pattern on the landmass below the horizon line and also to the shadow under the tree canopy. Use a fork or the back end of the brush to make the scratch marks.

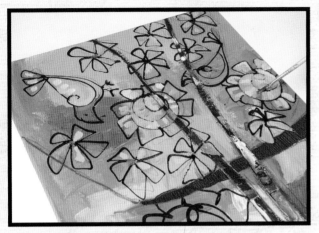

## 6 Add Pops of Color

Drop in some small patches of color to add more visual interest. Spread the patches around the canvas to lead the eye and unify the painting.

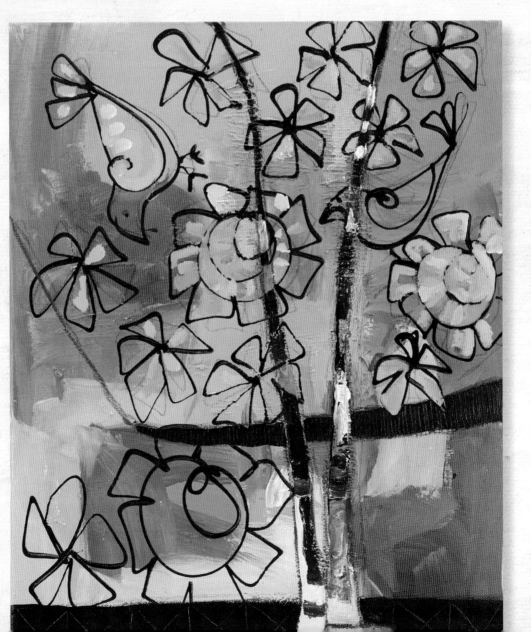

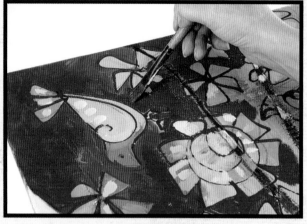

## 7 Paint the Background

Fill in around the shapes using several versions of the same color. Try not to use all one color from the tube but rather to shift that hue in a couple of different directions by adding other colors to it.

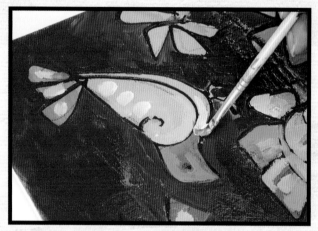

## 8 Paint the Birds and Flowers

Paint the birds and flowers with a wide variety of light warm tones from pale yellow to ochre and gold. Unexpected pops of brighter green keep the colors from getting boring and predictable.

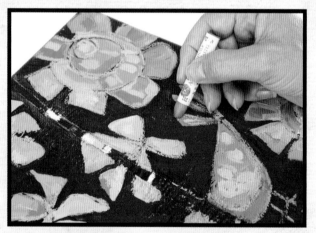

## 9 Final Details

Use oil pastels to add final details around the flowers, trees and birds.

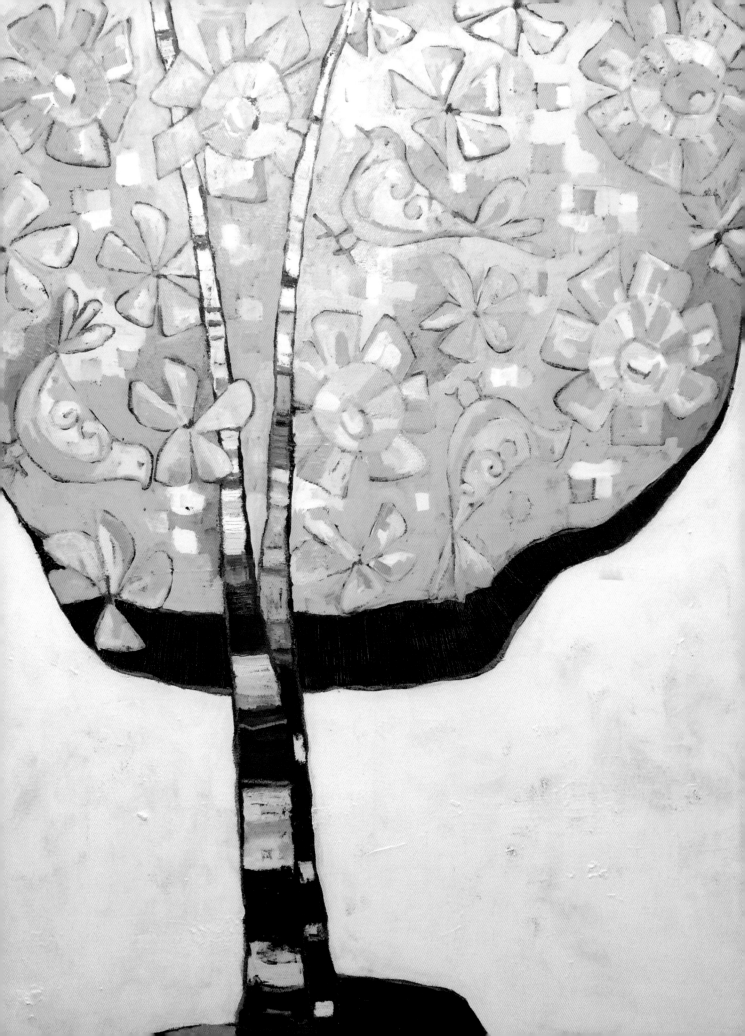

# Re-Marks

Occasionally I get too much paint on my canvas during the early stages of underpainting. Either I apply too much out of the tube while I'm editing out the white or I squeeze too hard and create red lines that are too thick. I admit I can get a little impatient waiting for all of that paint to dry! One way to speed things up a bit and create collage papers to use later is to pull prints off your painting along the way.

Experiment with different textures of watercolor paper. Hot-pressed paper is very smooth and will create a very different look than cold-pressed paper that has a coarser texture. You can purchase sample books of watercolor papers that will give you plenty of supplies with which to experiment. All of the collage paper in this book is cold-pressed.

You can pull a print off your painting at any stage along the way. Try pulling a print off your canvas after you've applied the red drawing layer to obtain a secondary patterned painting. Experiment and see what you prefer. You can use wet or dry watercolor paper. Instructions for using wet paper for printing are given below. On your own, experiment using dry paper for a different effect. Chances are you will get a spottier effect but that can be equally interesting.

## GRAB IT!

300-lb. (640gsm) watercolor rag paper

acrylic paints in a variety of colors

assorted brushes for painting

canvas

plastic bottle with squeeze top containing liquid paint

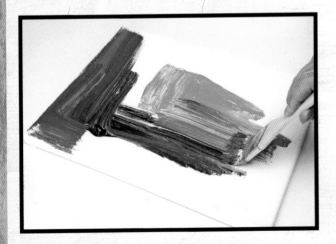

## 1 Prep Your Paper

Before you begin painting on your canvas, prepare a couple of pieces of watercolor paper by wetting them in a large sink or bathtub. The paper will swell and absorb a significant amount of water. Set aside.

Proceed with applying your first layer of acrylic paint to your canvas or board. Use slightly more paint than normal and you will get a stronger print.

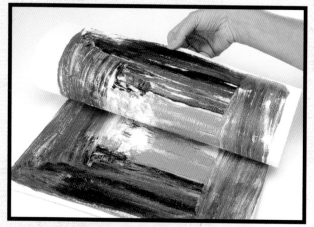

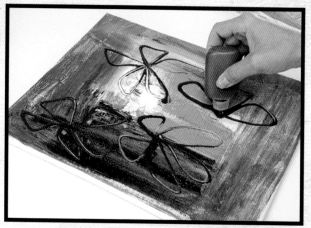
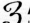

## 2 Pull a Print

Press the wet watercolor paper on top of your painting and rub over it with your hands. You can also use the back of a paintbrush or draw on the back of the paper. This will transfer paint to the paper in a more specific manner.

Starting at a corner carefully lift the paper off the canvas. Set aside to dry and use later.

## 3 Add Designs

Using a small squeeze bottle filled with thinned paint, draw designs onto the painted surface from step 1. Limit your designs to one or two and repeat them to fill the space. Too many different designs can appear cluttered.

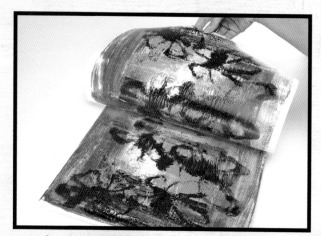

## 4 Pull Another Print

Reapply the paper from step 2 on top of your painting and rub it with your hands to transfer the paint. Alternative: Experiment by using a fresh piece of paper for printing.

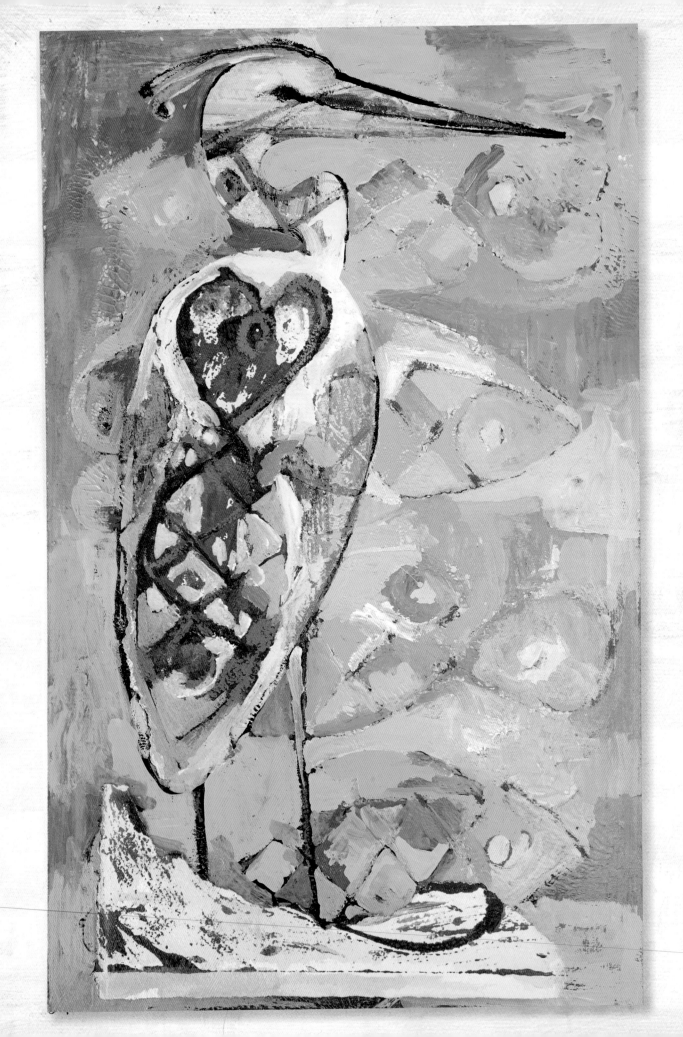

# Restless Loner

The graceful blue heron, his far-seeing gaze dreaming perhaps of fish dinner. Folklore tells us that the appearance of heron before a hunt or fishing trip foretells a successful trip. In this technique we will incorporate the heron's dream of fish into his environment as well as the decoration of his body by pulling prints and collaging them back into the artwork.

## GRAB IT!

10" × 16" (25cm × 41cm) Masonite

300-lb. (640gsm) cold-pressed watercolor paper

acrylic paints in a variety of colors

assorted brushes for painting

gesso

large brush for gesso

oil pastels

paint palette

plastic bottle with squeeze top containing liquid paint

thick glue or paste

water for rinsing brushes

### 1 Prepare the Background
Lay down a layer of gesso on Masonite. Let dry. Then cover the Masonite with acrylic paint.

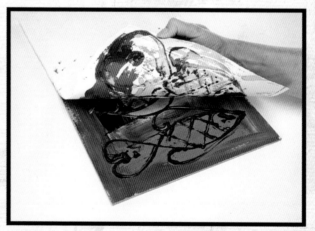

### 2 Draw Designs and Pull a Print
Tear a piece of watercolor paper in half so it is roughly the same size as your Masonite and wet it in the sink or tub. Set aside to give it time to absorb the water.

With the squeeze bottle of paint, draw fish designs onto the Masonite. While the paint is still wet, press the paper down into the paint to pull up a print.

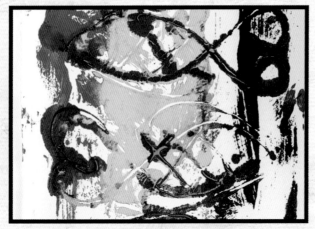

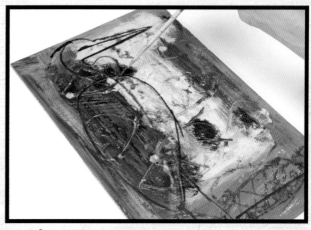

## 3 Let the Pulled Print and Masonite Dry
Save the pulled print for later. Let it and the background paint on the Masonite dry completely before the next steps.

## 4 Draw the Heron
Sketch out the image of the heron using a thin paintbrush dipped in dark paint. Try to use large crisp shapes. Let dry.

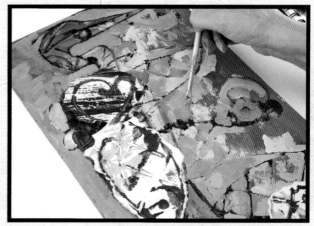

## 5 Add Collage Paper
Look for ways to incorporate the printed designs on the watercolor paper into the figure and background of your original painting. Here I chose to use one large fish and work it onto the folded wings of the heron. Tearing instead of cutting the print creates interesting rough edges. With thick glue, add the fish shape to the heron and add another piece of torn paper along the bottom edge.

## 6 Start Painting
Start painting the background. Keep some of the lines of the fish shapes that you drew on there earlier.

Complete your painting using colors of your choosing. The color story here is simple: teal for the figure of the bird, orange for the background. Lavender from the underpainting was preserved during the painting process to create a pleasing color scheme of secondary colors: green, orange, violet.

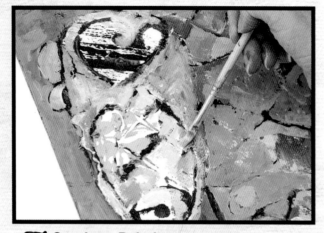

## 7 Continue Painting

Paint the heron and blend the collaged paper into the shapes of the bird. Leave some of the outlines from the fish shape as you paint.

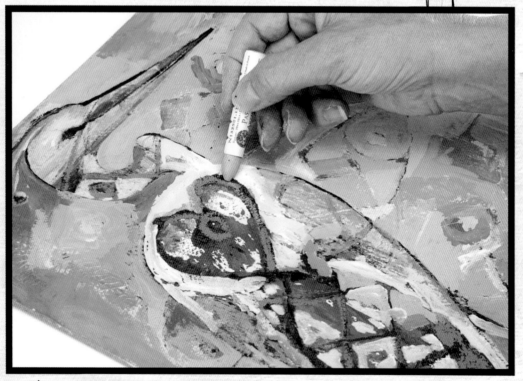

## 8 Final Details

Use oil pastels to blend any final areas and add final pops of color.

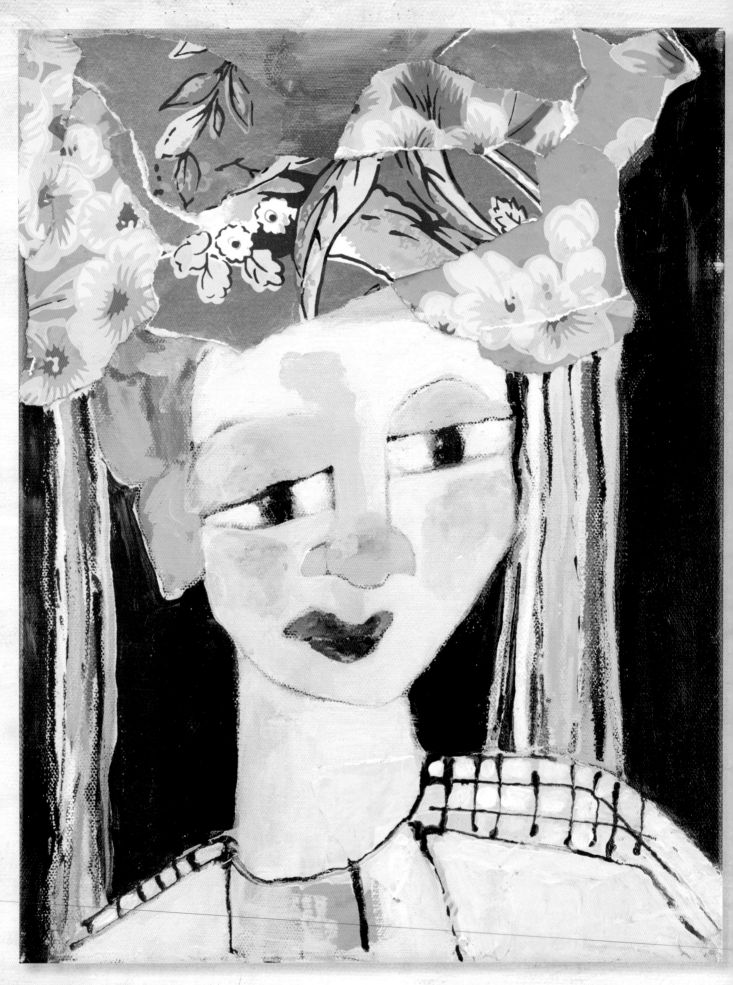

# CHAPTER 5

# Appearances

In the beginning of this book we took a look at the limited color palette and touched upon its benefits. In this chapter we will explore more specific methods for applying color that will expand the possibilities of such highly edited paint colors.

Let's say you are looking to paint the sky blue. Rather than reaching for a tube of blue paint or even using blue and white to mix a large puddle of one single shade, try this instead. Choose two blues and two whites as well as a smidge of red or yellow. I like Cerulean Blue and Phthalocyanine Blue with the occasional extra dab of Ultramarine Blue. Using a small brush, collect a bit of one blue and a bit of white. Start dabbing the paint in different areas of your sky section moving the color around everywhere so that you have small dabs of color. When you reload your brush choose a different combination of blue and white. And don't forget to add a scant amount of red to soften the color towards lavender to further expand your range of sky tones. Apply the dabs of paint throughout the blue area. Continue to do this until the entire area is filled.

Moving color around your entire canvas in this manner will create visual interest as well as texture. You may be surprised at the infinite number of colors you can create in an area using a limited number of tubes of paint.

# Cast of Characters

## A Peek Inside My Drawing Alphabet

### HOUSES

Okay. I am a nester. I'm fairly certain that the down comforter was invented for my own personal pleasure. I can go for days and never leave my house. I just enjoy my cozy familiar surroundings. Nothing makes me happier than a rainy February day with a cup of tea, my sketchbook and a cozy blanket to keep me warm. And chocolate chip cookies.

### GEOMETRIC DESIGNS

I love how design is ubiquitous. The same interconnecting shapes that form a border on delicate pysanky eggs can just as easily be found executed in fabric to become a quilt. The same designs remind me of the farm fields in Pennsylvania, all neat and tidy.

If I asked you to make a mental inventory of the design elements that speak to you deeply, the ones that hit you in the gut, what would you include in that list? Do you find that there is a common thread that ties them all together? Draw out your list in a sketchbook.

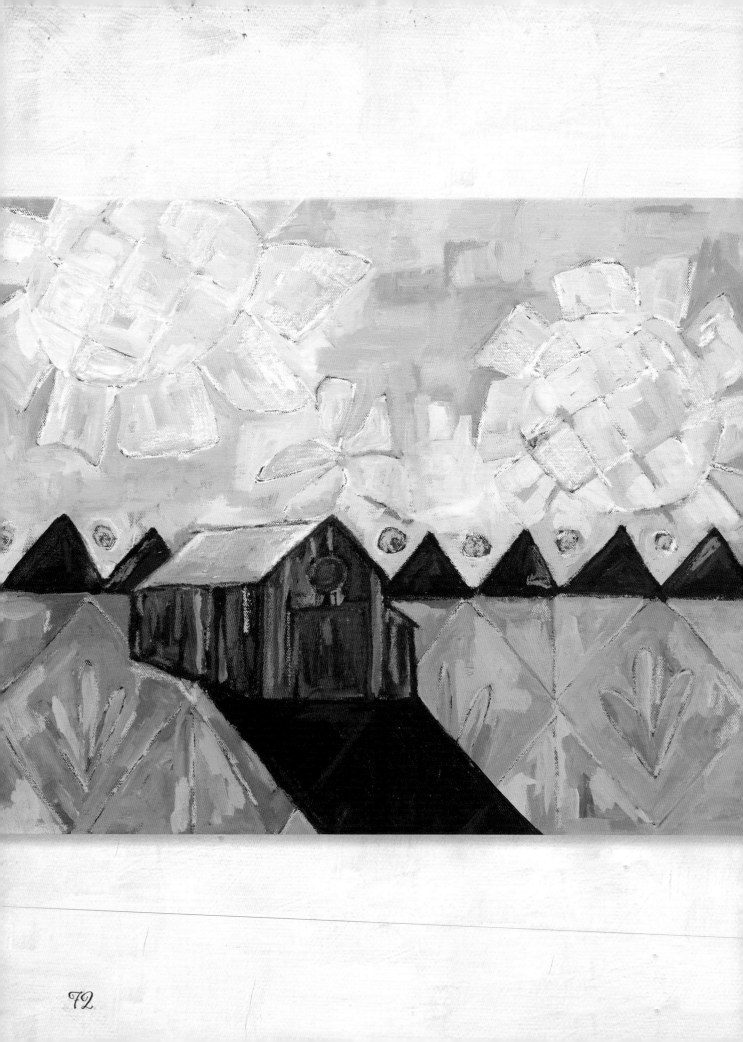

# Homestead

There is nothing like a simple composition of blue sky, green grass and a lovely red barn upon which to rest your eye. The basic division of two-thirds sky and one-third land punctuated with a structure placed in just the right spot provides the perfect backdrop for experimenting with pattern and color.

## 1 Prep the Background and Start Drawing

Paint the background using a variety of warm colors. This helps give a nice warm glow underneath the painting when it's finished. Measure up from the bottom approximately one-third of the height. Use an oil pastel in a dark color to draw a line across the canvas for the horizon line. Then draw in the barn shape.

## 2 Draw Geometric Designs

Using the squeeze bottle of paint, draw designs across your canvas. A repeating geometric design in the bottom third reminds one of planted fields. Large flowers in the top two-thirds can be interpreted as clouds. For an added twist you could use animals or people in this area as well to create a playful and whimsical feel.

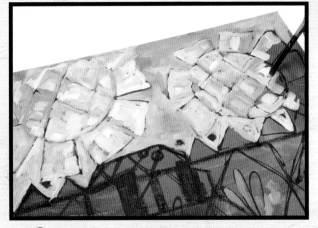

### 3 Start Adding Color

Use a small paintbrush and begin adding color to your painting. Remember that blue doesn't just mean one shade of blue but many. Every time you reload your brush dip it into a different blue mixture. Move the color around the entire sky area rather than filling it in one section at a time. In this way you will create a more unified color story across the canvas. Use quick varying strokes as you move around the canvas. Your strokes don't have to be perfectly smooth. Let some of the warm tones from the background show through to create a slight glow behind the blue.

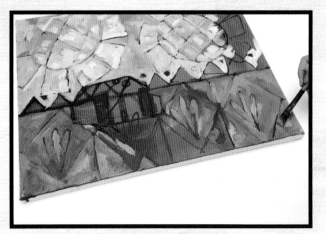

### 4 Continue Adding Color

With the same technique, use varying shades of green at the bottom to create the grass and planted fields. Fill in the designs you drew earlier.

### 5 Color the Barn

Paint the roof and walls of the barn. Let dry. Then use the oil pastels. Draw vertical stripes of color and create texture.

### 6 Final Details

Fill in the barn's shadow. A strong shadow helps to anchor it to the landscape and reinforces the idea of a light source in the sky coming from behind it.

Accent the painting using oil pastels. Subtle hits of white to the clouds give them form. Colorful accents to the red barn keep it from being predictable.

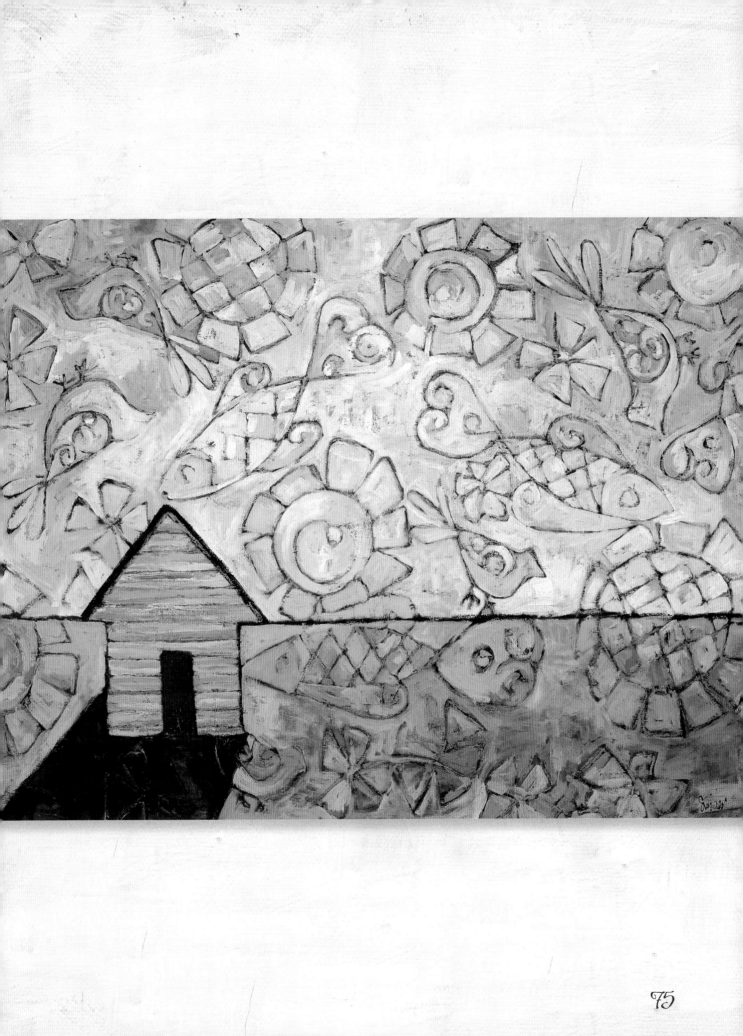

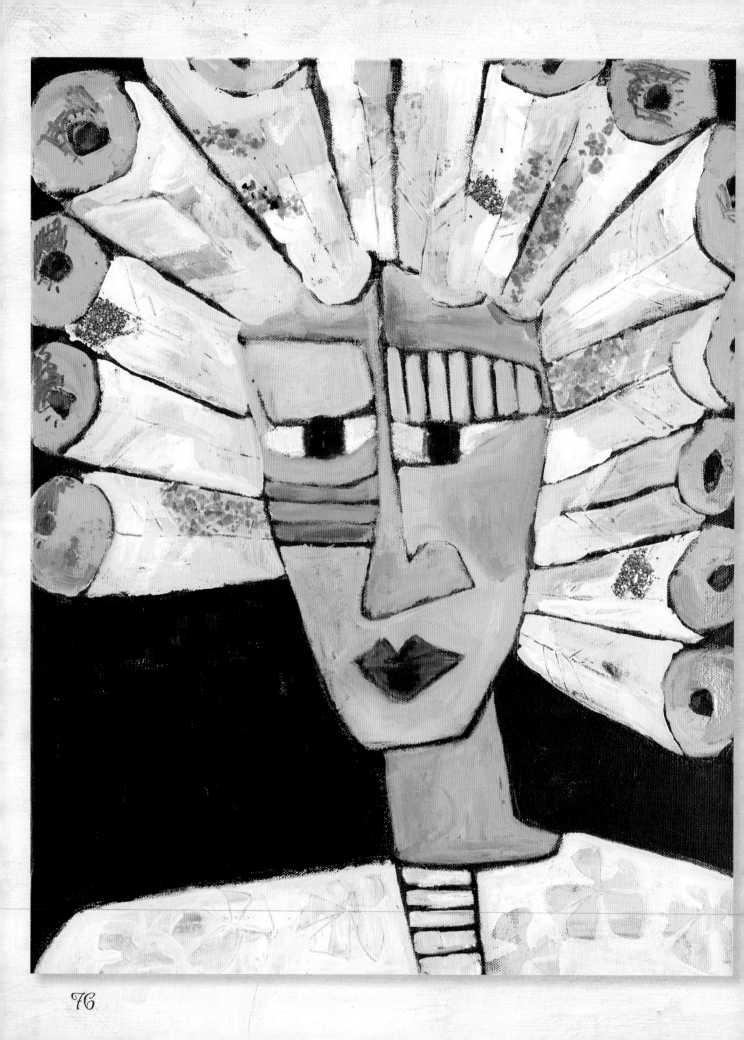

# Anni

Interpreting the gray hair of this wise woman as a well-earned headdress provides a surprising opportunity to get innovative with color, or in this case the absence of color. White or lightest lights can be achieved by adding the tiniest bits of color to titanium dioxide and unbleached titanium providing a beautiful, soft understory to your painting. Darkest dark is obtained by mixing Phthalo Blue with Burnt Umber and adding a touch of any red to the mix for a little variety. Well-placed additions of mica, silver glitter and gold paint pen underscore how special she really is.

## GRAB IT!

16" × 20" (41cm × 51cm) primed canvas

acrylic paints in a variety of colors

assorted brushes for painting

glue (I prefer Aleene's Tacky Glue for this type of application.)

gold paint pen

mica flakes

oil pastels

paint palette

silver glitter

water for rinsing brushes

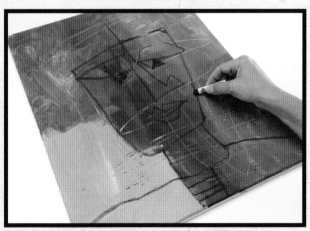

## 1 Prepare the Background and Find the Figure

After preparing your canvas by painting it using warm colors, use natural breaks in the underpainting to help sketch out a portrait with oil pastels. Look for lines and shapes created from color shifts underneath.

## Making Yellow Opaque

If you're using yellow and want it to be more opaque, add a small dab of white to the mixture.

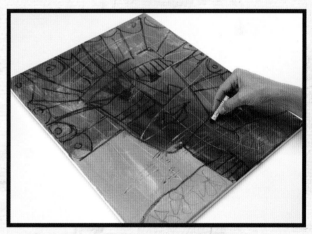

## 2 Define the Figure's Features

Continue sketching in details to give your portrait personality. When sketching eyes, try using a loose scribble with black or dark navy. I find that keeping the suggestion of the eye a little ambiguous lends an air of mystery and keeps my faces from looking too cartoonish.

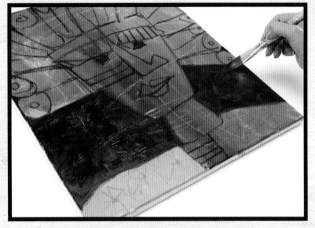

### 3 Paint the Background

Block out the background, painting with a dark color. If you don't like the face shape, now is also the time you can edit it. Cut into the drawn shape with the paint.

With the darker colors of paint, if you want good coverage you usually need to do more than one coat. Paint the first layer, let it dry, then paint another.

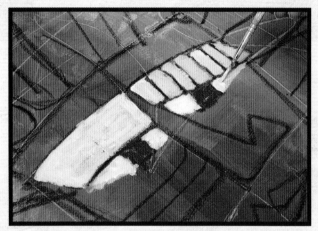

### 4 Start Painting the Figure

Just as the warm tones of the underpainting will give an overall glow to the final painting, adding a cool undertone to future white areas will help them to pop against the rest of the painting. Use a pale blue gray to paint the eyelids, whites of the eye and underside of the nose. Allow to dry completely before painting over these areas with a thin wash of light or white.

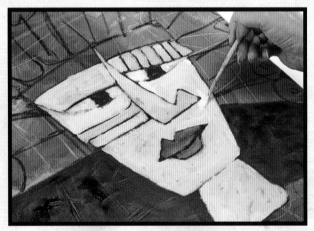

### 5 Continue Painting the Face

Mix a peach tone and start filling in the figure's skin. Making the color slightly more red on the nose and cheeks helps better define them and pull them forward.

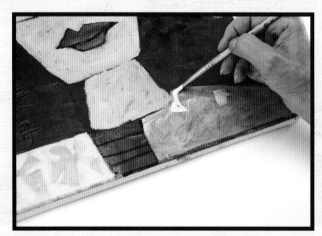

### 6 Paint the Garment

Paint a really thin wash of white for the shirt. Thin the white color with the water to let the color underneath show through. When painting with the white, mix it with some of the other colors on your palette so it's not a straight, clean, boring white. Then paint a second layer of the shirt with a thicker wash of paint, painting around the flower shapes.

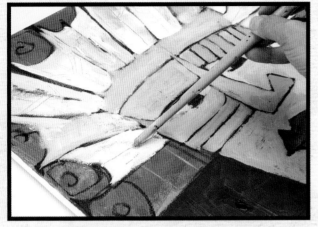

## 7 Paint the Feathers

Use thick layers of paint to fill in the feathers. Paint strokes of multiple colors. As you go, scratch into the wet paint with the end of your paintbrush to indicate the lines of the feathers.

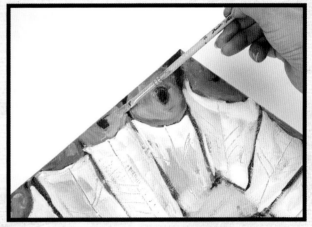

## Natural White

When using white paint, I like to mix it with some dirty water as I paint. This helps make the white look more natural and not so stark and pure on the canvas.

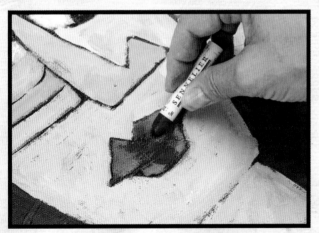

## 8 Add More Details to the Face

Use the oil pastels to add more white to the eyes and build up the lips with red.

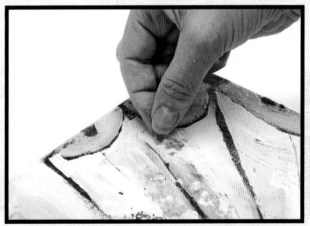

## 9 Final Details

Use a gold pen to draw a few other details on the feathers. Then use mica or glitter on the feathers. Put down a little glue where you want the mica to stick, then sprinkle the mica over the glue. Let dry.

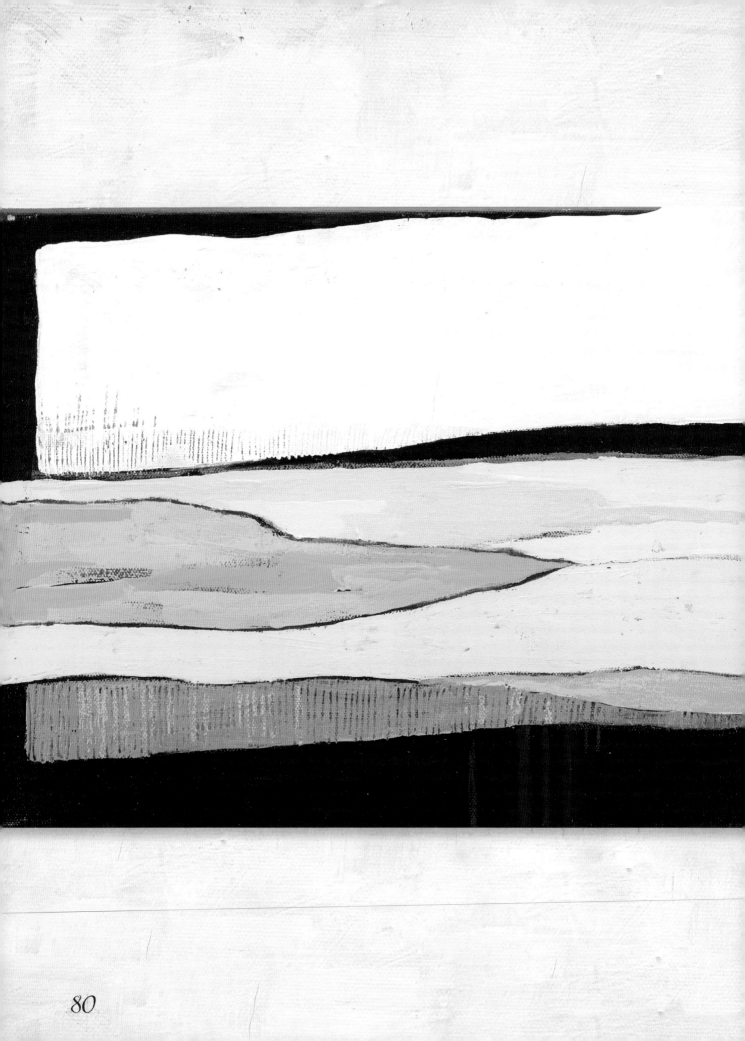

# CHAPTER 6

## Style

There is something visually satisfying about an antique shop full of older artworks and furniture. The gentle glow of patina on worn furniture and the soft overall quality of color in a painting that's been around for a long, long time. In this often hectic and stressful world there is a quiet calm to the muted colors from layers of age and dust and the rounded edges of well-loved wood.

There are several ways in which to achieve this effect on your own artwork without having to wait one hundred years or more. Sanding and rounding over corners of wooden panels is a simple way to literally take the edge off a piece of artwork. Glazing techniques can unify paint colors as well as highlight key areas and make whites look whiter while softening surrounding areas. Encaustic wax applied over a painting is a more extreme method that can be used to really alter the mood of the finished work and can be quite beautiful. Let's take a closer look.

# Cast of Characters

## A Peek Inside My Drawing Alphabet

### BIRDS

There is a family of geese that brings their babies up on shore here to nibble on the grasses and weeds. The birds I use in my paintings are fairly nondescript and are an abstraction of a simple bird I copied from a traditional egg design. This design has morphed over the years through repetition. I might change the leg or neck length every now and again, but basically she's always the same gal.

### FERNS

I love the repetition of the leaves. I imagine fairies and the like living in a secret world underneath the fern canopy that covers the ground in the woods around the house.

### POND LILIES

When these beauties come up on the water in the spring, they are the size of a quarter and are so darling. By the time summer is in full swing they are the size of a dinner plate and can quickly choke out the shoreline. I have a love/hate relationship with them.

Choose a few characters that occur repeatedly in your life: a plant or tree, a wild animal, a favorite pet. Practice drawing that image over and over again until you can do it without thinking. Watch how the image morphs and transforms to its most basic essence under your pen or pencil. Do this every time you add a new design element to your repertoire.

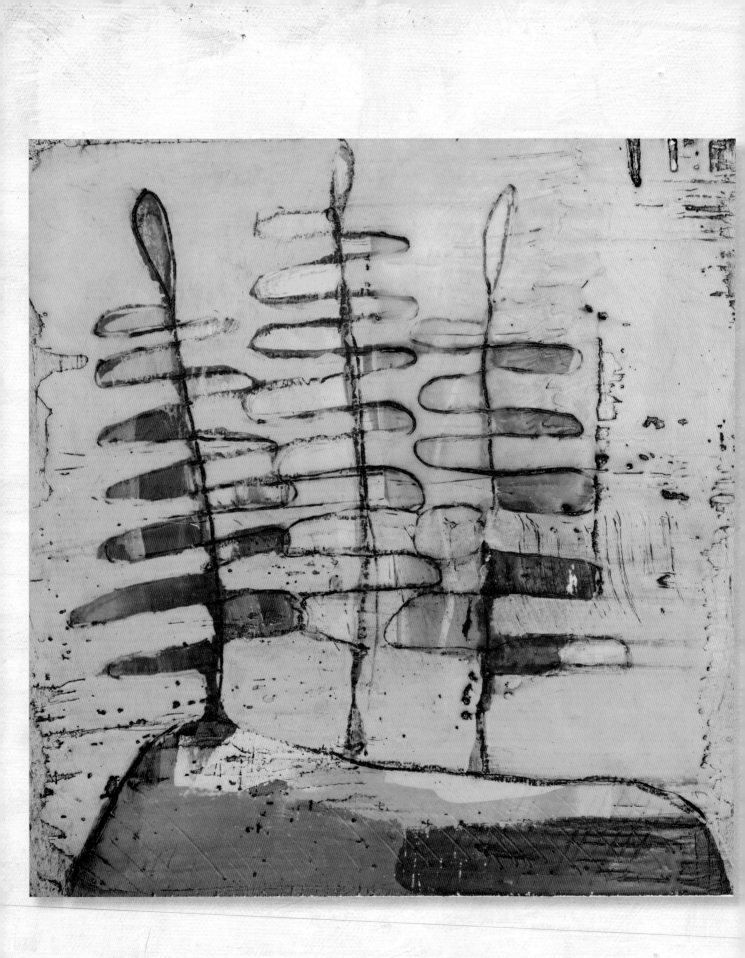

84

# Shade Dweller

When antiquing with encaustic wax it is important to work on a rigid surface such as wood or hardboard panel. When the wax is dry, it lacks flexibility and you risk cracking or breaking if it is used on stretched canvas. Applying the wax in an uneven manner allows for surface texture that can be highlighted using an oil paint stick. Sgraffito outlines or designs can further enhance the final painting. The softness of the colors underneath the wax layer combined with a drawing seemingly floating across the surface creates a finished product unlike any other.

## GRAB IT!

acrylic paints

assorted brushes for painting

black oil paint stick

boiled linseed oil

clear encaustic wax

cotton swabs

gesso

heat gun

hot plate

paper strip for collage

soft brush for applying wax

soft rag for rubbing and removing

tin for holding melted wax (Old tuna cans work great.)

wood panel

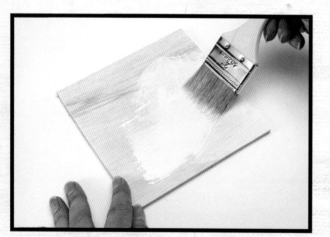

### 1 Prepare the Board
Cover the small wood board with white gesso. Let dry.

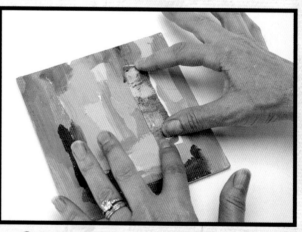

### 2 Paint the First Background Layer
Paint the background with a variety of colors then collage a strip of paper onto the piece. Let the paint dry.

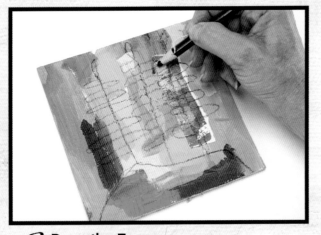

## 3 Draw the Ferns

Once the background paint is dry, draw three ferns onto the board with an oil paint stick (or oil pastels).

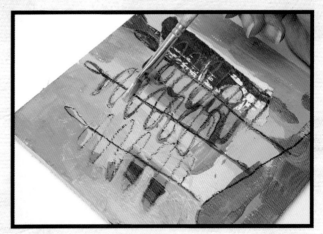

## 4 Paint the Background

Fill in the background around the fern leaves with acrylics. Let the leaves show the original colors you painted earlier.

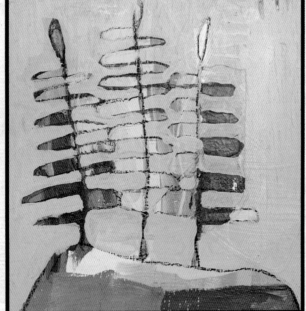

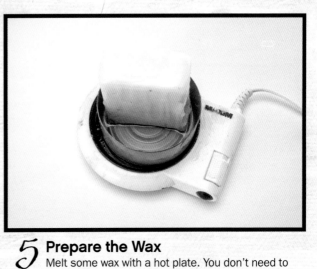

## 5 Prepare the Wax

Melt some wax with a hot plate. You don't need to melt a lot of wax.

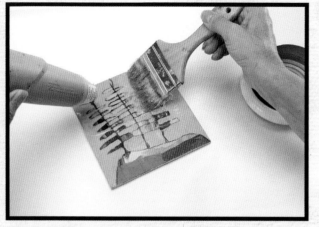

## 6 Start Adding Wax

Using a heat gun in one hand, warm up the wood board you painted. Then with the other hand, brush on the melted wax using an old brush.

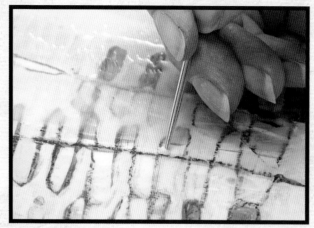

## 7 Add Texture

Once the wax has solidified, use a sharp tool to scratch into it to outline the ferns and add visual interest.

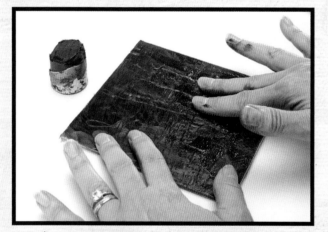

## 8 Add an Antique Effect

Use an oil paint stick and linseed oil and a soft rag (an old T-shirt or cheesecloth) to add an antique effect to the piece.

Cover the entire piece using the black oil paint stick. You can use your fingers to spread it across the entire piece.

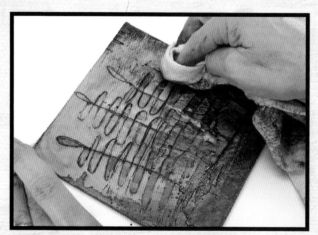

## 9 Finish the Antiquing

Put some linseed oil on the rag. Drag the linseed oil covered rag across the piece and rub off the oil paint stick. If there are any small areas the rag isn't picking up, use a cotton swab.

If you rub off too much of the oil paint, you can always go back and add more. Just keep working the piece and pulling up the black until you're satisfied with the antique look.

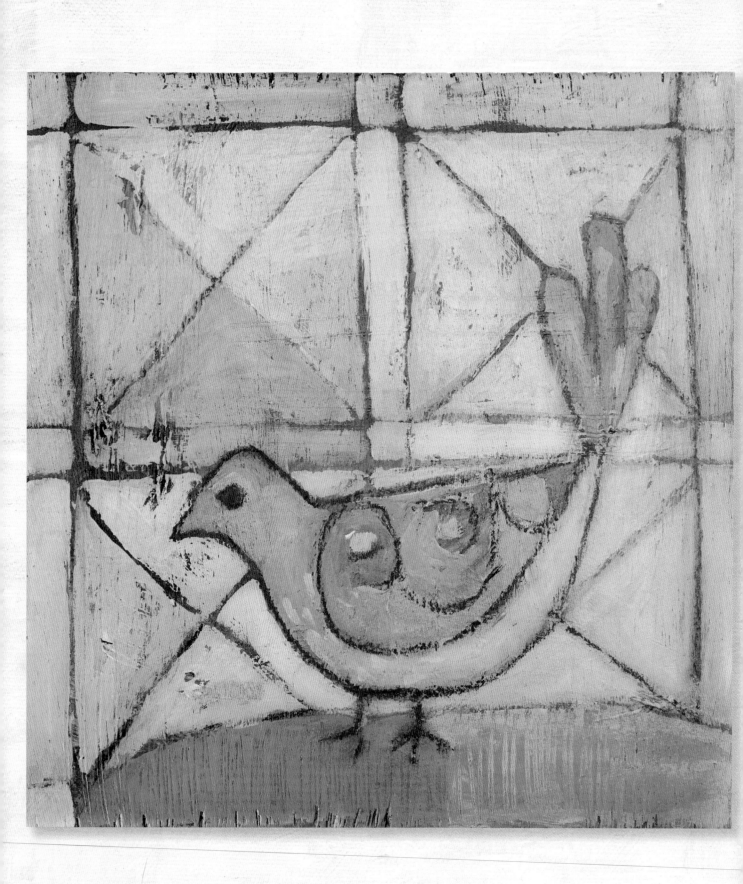

# Aflutter

Liquin mixed with Burnt Umber or any other dark neutral oil paint applied as a glaze over paintings has been used for decades by oil painters. It can be applied over acrylic or oil paint but in the case of acrylics must be done as a very last step. Once applied you can *not* apply acrylic paint back over the top of it. There are two types of Liquin and for our purposes here we will be using Liquin Original. I prefer to use it when I wish to soften the overall tone of a painting and to highlight texture while giving an aged quality. Because these are oil-based products, I prefer using disposable materials in order to avoid the need for turpentine cleanup.

## GRAB IT!

acrylic paints

assorted brushes

Burnt Umber oil paint

clean soft rag such as an old white T-shirt

disposable plate or dish

gesso

Liquin Original

oil pastels

wood panel

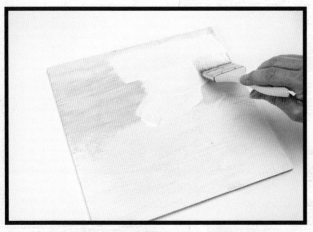

## 1 Gesso the Panel
Cover the wood panel with a layer of gesso to prepare the surface. Let dry.

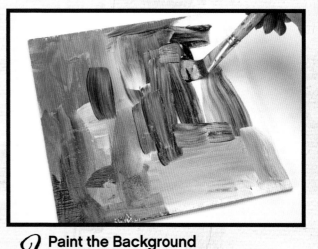

## 2 Paint the Background
Use a variety of blue shades of acrylic to cover the background. The idea is to have as much variety as possible as opposed to a solid covering of all one blue. This can be achieved simply by mixing in different amounts of white as you move across the surface.

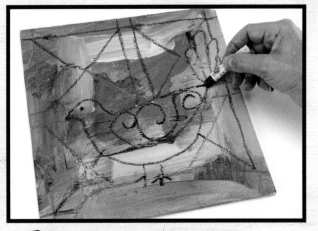

### 3 Draw Designs

Use the oil pastel to draw your designs onto the board. Draw the bird and block out the shapes.

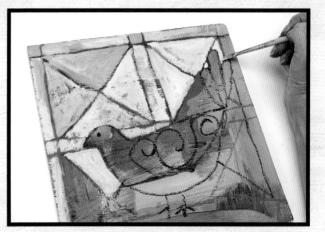

### 4 Start Filling in Shapes

Paint inside the shapes you drew, painting up to the oil pastel lines but not over them. When you're painting on a wooden board like this, you can use the paint thick and not thinned out with water.

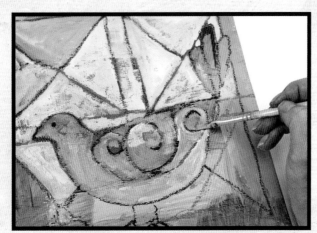

### 5 Paint the Bird

After you've painted the geometric shapes in the background, work on filling in the bird.

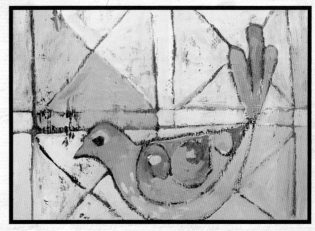

### 6 Continue Painting

Continue working around the piece and filling in the blocked out shapes with color.

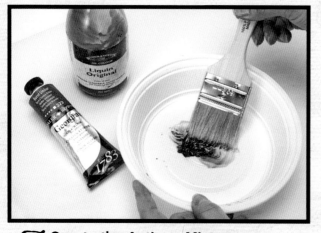

## 7 Create the Antique Mixture

Use Liquin Original to add an antique look to the piece. Liquin is an oil-based product, so it's a good idea to use disposable materials so you can just toss them instead of having to clean them up. Mix Liquin Original with Burnt Umber.

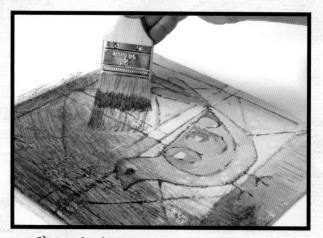

## 8 Apply the Mixture

Once you have the two mixed together, brush the whole piece with the antique mixture.

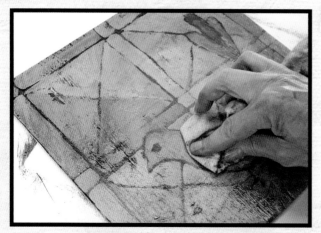

## 9 Rub Off the Mixture

Use an old rag to buff off the excess of the antique mixture. Work with it until you're happy with the look. Rub the mixture between the oil pastel lines to try to preserve the oil pastel. Sometimes the Liquin can remove the pastel.

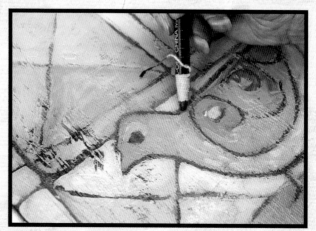

## 10 Final Details

If the Liquin mixture took off too much of the pastel, go back in and redefine those pastel lines.

# Pond Lilies

Here is a comparison of three similar paintings, each treated with a different finishing technique. All three of these were initially painted with the exact same colors, and you can see how the wax and Liquin affect the colors in subtle and not so subtle ways.

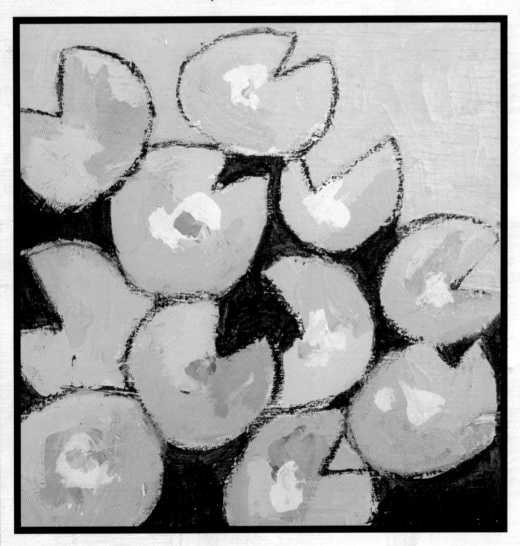

**Finishing with Paint Only**
This is the original painting without any antiquing. I stopped working on it after painting. You'll notice that the colors and shapes are crisper and brighter. This is a perfectly acceptable ending point for this little study of water lilies, and I like all of the different shades of green as well as the definition of the blobs of white flowers.

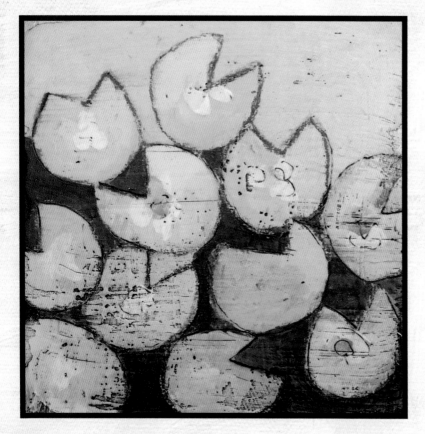

### Wax Finish

Here the lilies take on a much more textured effect with the addition of the encaustic wax technique. After painting in exactly the same manner as the first example, I covered the surface with melted encaustic wax and then rubbed it with a black oil paint stick. This version has more surface interest than the other two, and I like how the small dots of black from the texture tie into the black in the background.

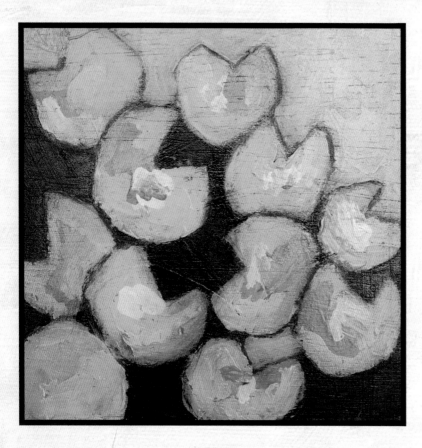

### Adding Liquin

Antiquing with Liquin and Burnt Umber really softened the overall effect of this painting. The colors look more unified and the creamy flowers are no longer as sharp. Everything has a subtle warm glow about it. The Burnt Umber really brings out the orange accent colors used to paint the lily pads.

# CHAPTER 7

## Accents

Years ago after a home remodel I found myself knee-deep in stacks of interesting shaped scraps of plywood and other vintage barn wood. The wheels in my head started turning and I began painting unusual animals on these shapes. Eventually I used up that supply and learned how to use a jigsaw to cut my own pieces, this time with more forethought and planning. Once you get the hang of it, the cutting is quite fun and can really open up a world of possibility. My preference is to use an orbital jigsaw because it provides a better turning radius for cutting curves.

If cutting wood is out of the question, you could easily recreate the following projects out of heavy cardboard cut to shape with a mat knife and glued in layers to your desired thickness. Covering the edges with copper foil, demonstrated in the next chapter, makes for an interesting edge while masking the cardboard substrate. Now that's taking folk art to a new level!

# Cast of Characters

## A Peek Inside My Drawing Alphabet

### CATTAILS

These water plants grow much taller than I imagined. They routinely get to six feet tall at our pond and watching them sway in the breeze is very soothing after a long day of painting.

### BARNS

There is something about growing up in Pennsylvania that speaks to me of barns. Stone barns. Red barns. I think the romanticism of an old barn goes back to my nesting instinct. Barns give me a sense of connection to people who came before me. I imagine family items put away in a barn and forgotten, waiting to be discovered by later generations. You never know what you will find while exploring there.

### GRASSES

The wild nature of the shoreline here. Everything here grows up in a clump of grass from the bottom. There is nothing tame whatsoever. The grasses are really a foundation for everything else. They grow so thick that they creates their own tiny islands at the edge of the water, their own tiny little three foot ecosystems. Occasionally I will find a nest where someone or something has crawled in there. Such a cozy little sheltered spot out there with a fabulous view of nature.

Where do you go when you wish to reconnect with yourself or nature or family? Do you have a favorite chair in which you sit to dream? Or perhaps you are someone who prefers to jog a few miles to clear your mind and tune in to inspiration. What color are your favorite running shoes? What color is energizing for you? What color do you find the most relaxing?

# Powerful Tools

It is not my intention to teach you how to use a jigsaw here but merely to show you some possibilities should you get tired of squares and rectangles. If you have never used a jigsaw, you can always draw your shapes on the wood and ask someone else to do the cutting for you. If you have experience using power tools, let's take a quick review of safety just to refresh.

1. Always wear safety goggles. I take this one step further and always wear a mask to keep the sawdust from being inhaled.
2. Always unplug or remove batteries before making any adjustments to the blade, etc.
3. Keep the jigsaw and all power tools stored out of the reach of children.

### Orbital Jigsaw vs. Reciprocating Jigsaw
A jigsaw cuts with a very narrow blade that allows you to turn corners and make all manner of interesting shapes on which to paint. The difference between the two is that the blade on the reciprocating jigsaw goes only up and down while the blade on the orbital jigsaw also moves forwards and backwards, which allows for a more aggressive cut.

### Palm Sander
This is perhaps my favorite power tool. I use it for everything from sanding cut wood to quickly rubbing down layers of paint and collage. It is invaluable for smoothing over the edges of cut wooden shapes. The sandpaper that you attach comes in a variety of coarseness, making it even more versatile.

### Safety Goggles
I cannot stress enough the importance of safety around power tools. Do not, I repeat, *do not* use any of the above tools without proper eye protection! Small slivers of wood or sawdust in your eyes are not only dangerous but just think of all of the creative time you will lose while you recover from an injury with a patch over your eye. Please, an ounce of prevention goes a long way.

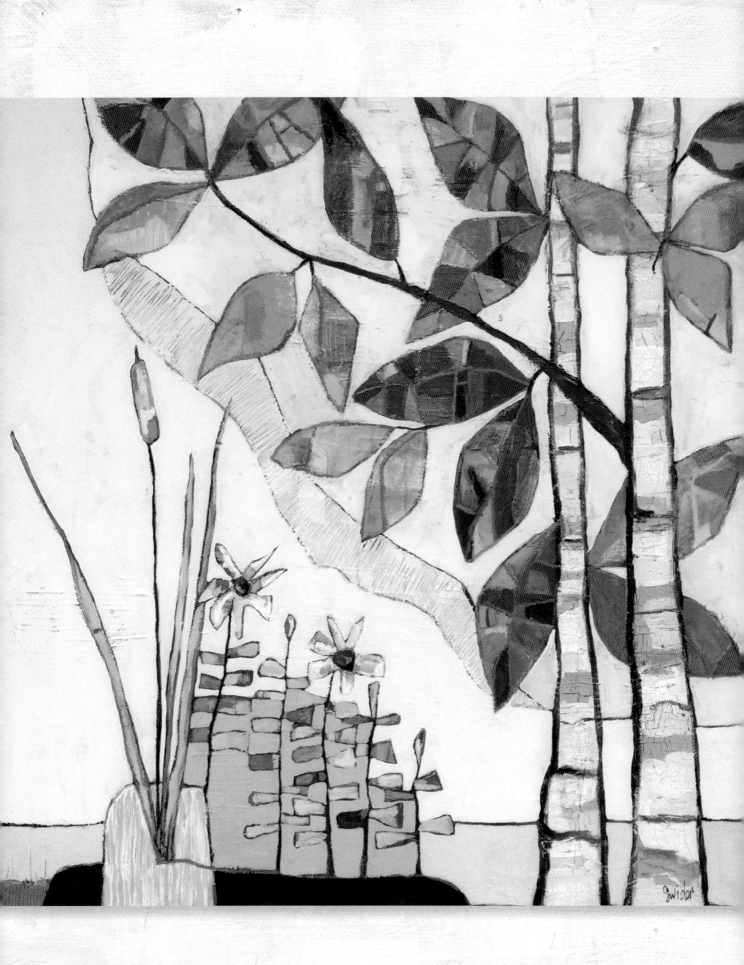

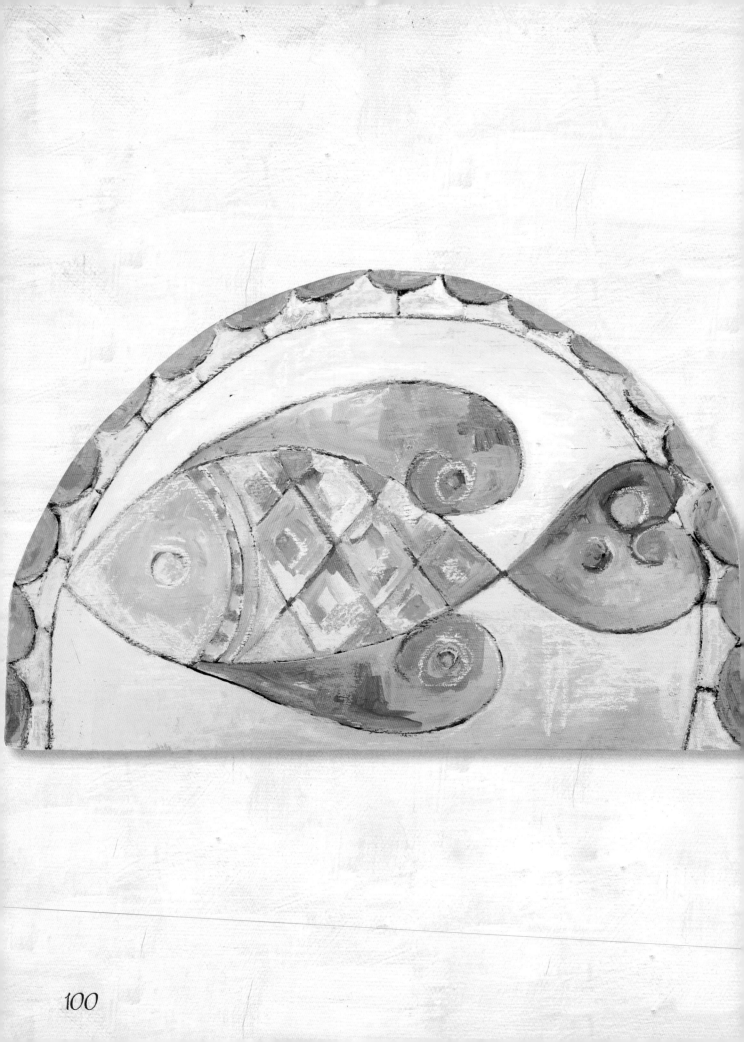

# Abundance

A curved arch above a window or door frame is such a pleasing shape. Even if your walls are covered in artwork, it seems that every home has an extra 18"–24" (46cm–61cm) above a door or window or above a larger piece of artwork for that matter. This fellow is done on a more severe curve but would look equally charming on a long, low curved piece as well. And if curves aren't your thing, adapt this design to a long horizontal rectangle.

## GRAB IT!

¼" (6mm) luan plywood, cut to shape (or a long narrow canvas 10" × 30" [25cm × 76cm] or 18" × 36" [46cm × 91cm] for instance)

acrylic paints in a variety of colors

assorted brushes for painting

gesso

Gorilla glue or similar

jigsaw, safety goggles, face mask

oil pastels

old newspaper

paint palette

plastic bottle with squeeze top containing liquid paint

sawtooth hanger

scissors

thick marker or pencil

water for rinsing brushes

## 1 Draw the Arch

Fold a piece of newspaper in half and sketch out a pleasing curve, making sure that the middle straight edge is up against the fold of the paper. Cut out. Open up the paper so that you now have a complete arch. Lay the pattern down on top of the wood and trace the shape.

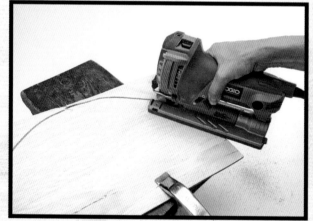

## 2 Cut the Wood

Cut out the arch using a jigsaw. Remember to wear safety goggles and a dust mask. You may need to brace the wood piece against something as you cut.

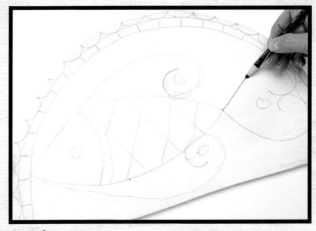

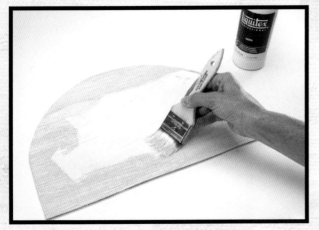

## 3 Apply Gesso
Prime the wood with gesso and allow to dry.

## 4 Draw the Fish
Once the gesso is dry, draw the fish design with pencil.

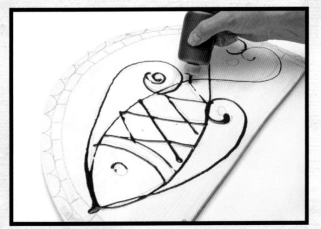

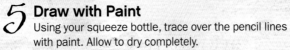

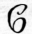

## 5 Draw with Paint
Using your squeeze bottle, trace over the pencil lines with paint. Allow to dry completely.

## 6 Start Adding Color
Paint your design by filling in the shapes with a variety of monochromatic tints and shades. Blue and many of its cousins were used on this fish. Variety was added by using white to create numerous tints. Keep the paint thin and loose so it looks more wet, like water, to go along with the fish design.

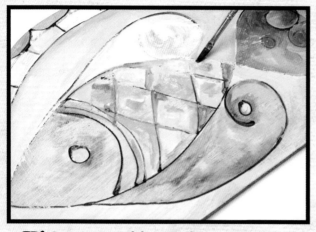

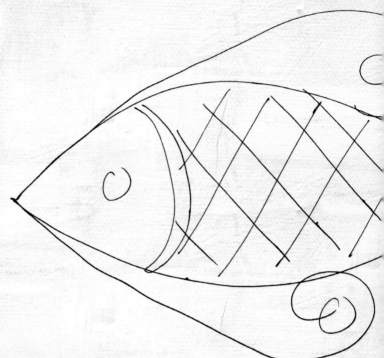

## ℱ Continue Adding Color

Continue working around the piece and filling in the shapes. Even with the gesso, the color can get sucked up into the wood. So you may have to paint a few layers to get the look you want.

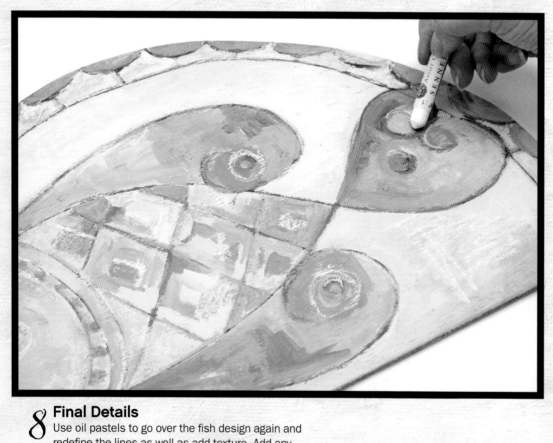

## 8 Final Details

Use oil pastels to go over the fish design again and redefine the lines as well as add texture. Add any other final accents and pops of color that you want.

Using Gorilla Glue or a similar glue, attach a sawtooth hanger to the center back. Hang and enjoy!

104

# Indian Red

This painting project started out as an exercise in color and design. Painting on wood and designing it as you would a piece of fabric, which you can then cut apart and reassemble, has so many possibilities it makes one's head spin. Animals, people, trucks and cars are but a few. Let's start with a simple landscape and see where your inspiration leads you next! If you aren't quite ready for cut wood, use cardboard. If using cardboard, applying gesso to both sides can help prevent warping.

## GRAB IT!

¼" (6mm) luan plywood, 16" × 20" (41cm × 51cm) or larger

acrylic paints in a variety of colors

assorted brushes for painting

cardboard scrap, approx. 3" × 3" (8cm × 8cm)

embossing tin (optional)

gesso

Gorilla Glue or similar

jigsaw, safety goggles, face mask

large brush for gesso

oil pastels

paint palette

palm sander or sandpaper

pencil

plastic bottle with squeeze top containing liquid paint

scissors

water for rinsing brushes

### 1 Apply Gesso
Cover your wood piece with a layer of white gesso. Let dry.

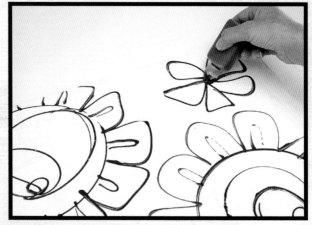

### 2 Draw Your Designs
Use the small squeeze bottle of paint to draw flowers all around the board. Repeat the design several times across the surface. It's okay to run the design off the edges too.

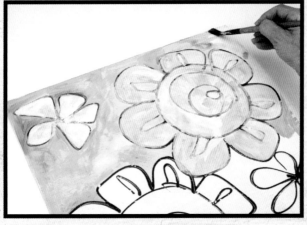

### 3 Start Painting

Starting at one edge of the wood, begin filling the shapes using many tints and shades of blue. Experiment with mixing two blues together and altering the color with a bit of red or magenta and white.

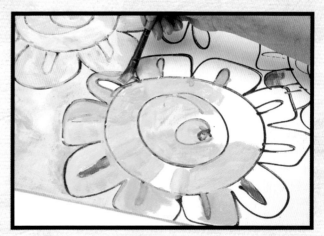

### 4 Continue Painting

As you move across the surface, begin to start adding bits of yellow to your blue to create green. Experiment with different blues and yellows plus white to create as many greens as you can.

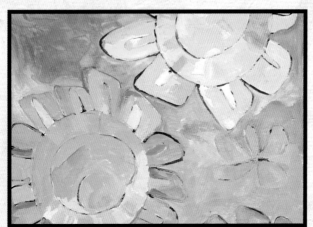

### 5 Complete the Painting Process

Continue to paint and cover the whole piece. Play with the varying shades of blue and green, keeping it loose and fun.

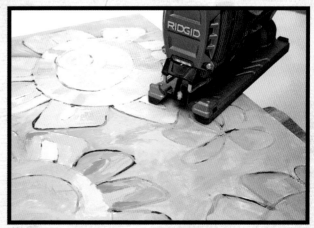

### 6 Cut the Wood Into Pieces

Once your piece is dry, look for natural divisions of space. Here the blue area is clearly defined against the green. Figure out where you want to cut the wood. You can freehand it or sketch pencil lines to help. Use a jigsaw to cut out the shapes.

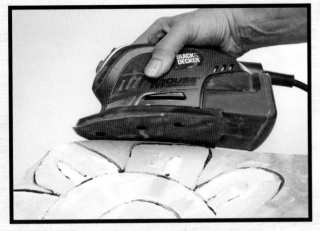

## 𝒯 Sand the Edges

Smooth out the rough cut edges with sandpaper or a palm sander. You can hold the wood piece over a trash can to catch the sawdust.

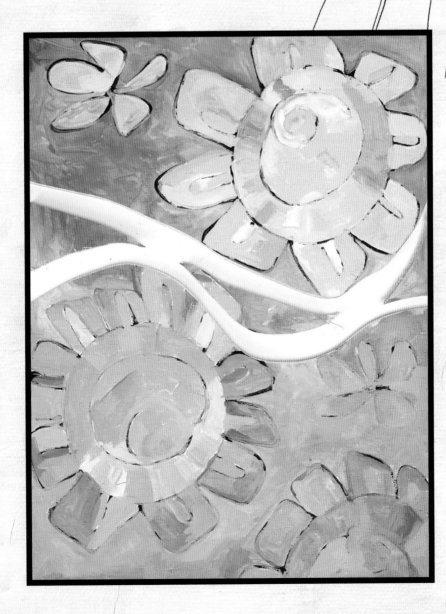

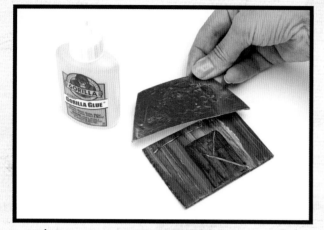

## 8 Create the Barn Shape

Cut a small rectangle or square from cardboard and paint it red. Add a door and line details to simulate wood. If you have embossing tin, this is a good use for those small scraps. I cut my roof shape and turned under the sharp edges. You can also use tinfoil or simply cut a roof shape from another piece of cardboard and paint it. Attach the two pieces together using a strong glue.

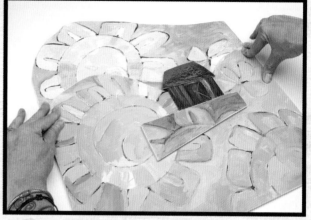

## 9 Glue the Pieces Together

Experiment with ways of arranging the two pieces of wood together. Here I turned the blue section upside down so that the curved edge is now the top. Apply a liberal strip of glue on the back of the bottom section and attach it to the top. Place a book or something heavy on top of the sections to hold them together while they dry.

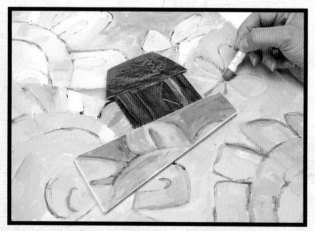

## 10 Final Details

Use the oil pastels to draw over the designs again and redefine the lines.

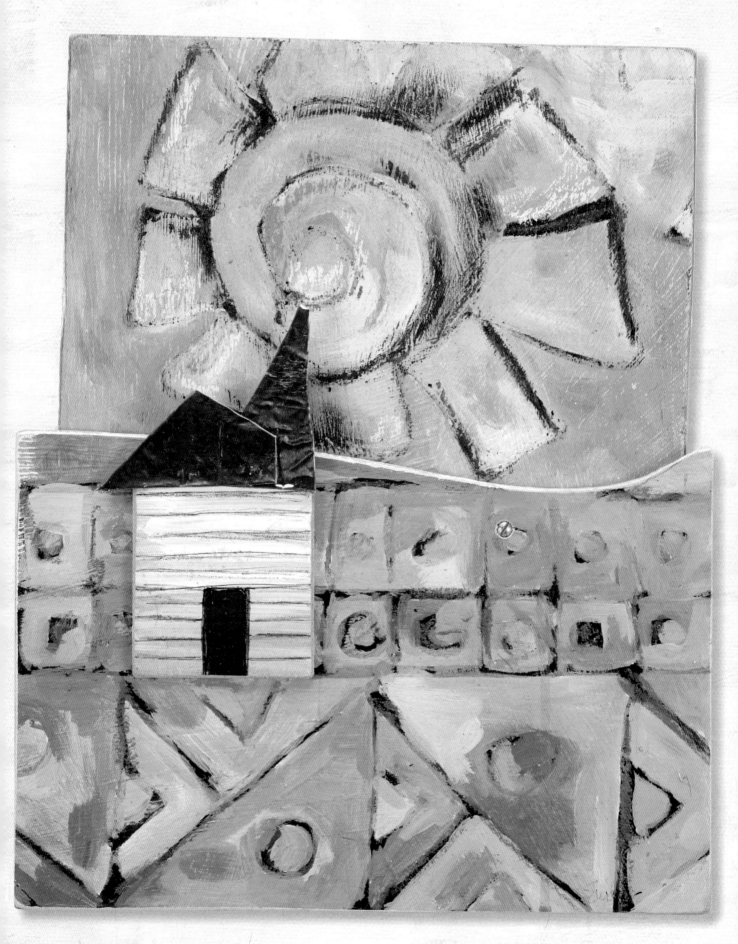

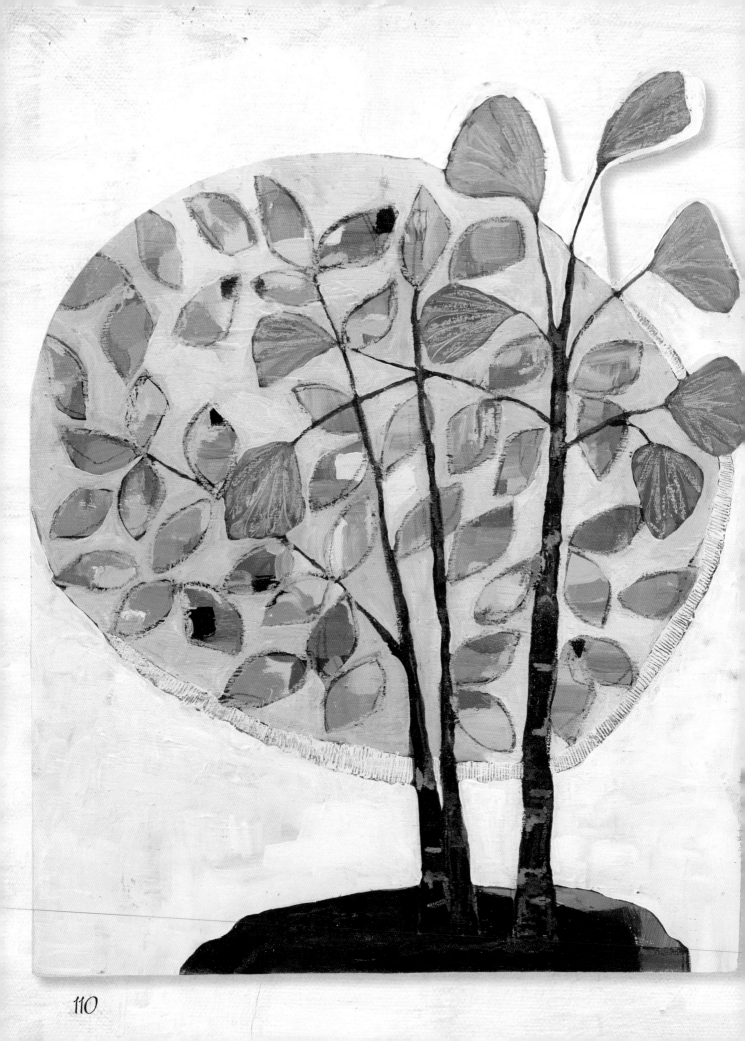

# An Understood Relation

I really love how the organic edge at the top of this project gives the trees breathing room and makes them feel so much grander. It's as if their life force is so big that it simply can *not* be contained within the confines of a standard rectangle or square. Imagine how exciting those trees would be painted five feet tall and hung over a fireplace! Hmmm. Now my wheels are turning.

## GRAB IT!

¼" (6mm) luan plywood, 16" × 20" (41cm × 51cm) or larger

acrylic paints in a variety of colors

assorted brushes for painting

gesso

jigsaw, safety goggles, face mask

large brush for gesso

oil pastels

paint palette

palm sander or sandpaper for smoothing cut edges

pencil

water for rinsing brushes

## 1 Apply Gesso
Apply a coat of gesso to seal in the surface of the wood and unify the background.

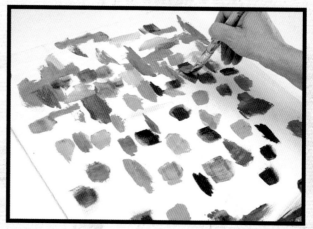

## 2 Paint Patches
Using short brushstrokes and a variety of colors, paint the entire surface of the wood. Experiment with different sized brushes as you progress to create interest. You will have a patchwork effect when you are finished.

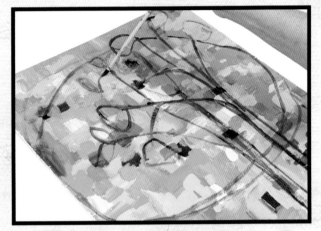

## 3 Draw the Tree Shapes

Lightly sketch out a tree design and leaf shapes using a pencil. Make sure that at least part of your tree extends to the edge of the wood. Once you are satisfied with your design, trace over the pencil lines using a thin brush and a dark color.

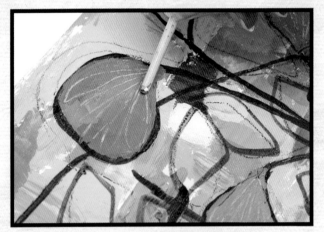

## 4 Start Painting the Leaves

Paint the large green leaves, then use the end of your brush to scratch lines into the wet paint.

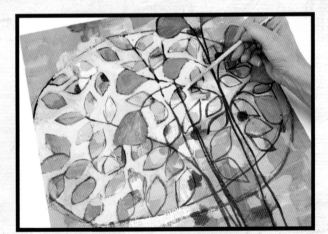

## 5 Paint Around the Leaf Shapes

Fill in the shapes behind the leaves so they pop out. This is called "negative painting," which is creating a shape by painting the area around it rather than the shape itself. Paint a blue sky color behind the leaves. The leaves are filled with a variety of color because of the multiple patches of paint you created earlier.

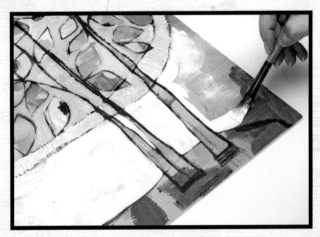

## 6 Fill in the Background

Block out the rest of the background beneath the tree canopy with white.

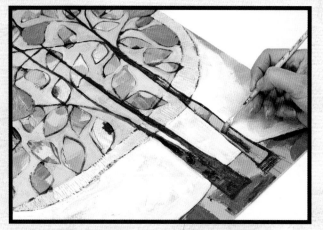

### 7 Paint the Tree Trunks

Paint the tree trunks and the rocks beneath. Continue painting until you are satisfied with your piece. A halo effect was created under the tree by painting a light yellow and scratching through the surface.

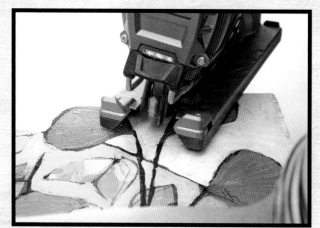

### 8 Cut the Wood

Using a jigsaw, cut off the top edge of the composition by following the outside edges of the tree.

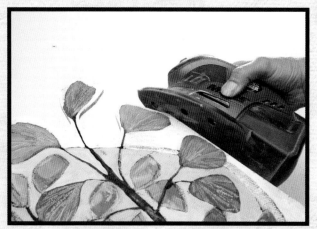

### 9 Sand the Edges

Smooth out the edges of the cut wood with a power sander. You can use sandpaper by hand to get into the tight corners around the smaller leaves if you have trouble maneuvering the large sander.

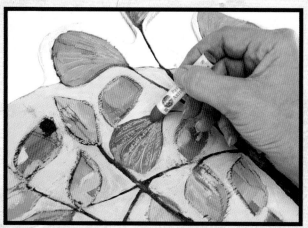

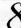

### 10 Final Details

Use the oil pastels to go back in and add final details and texture to the tree bark and around the edges of the leaves.

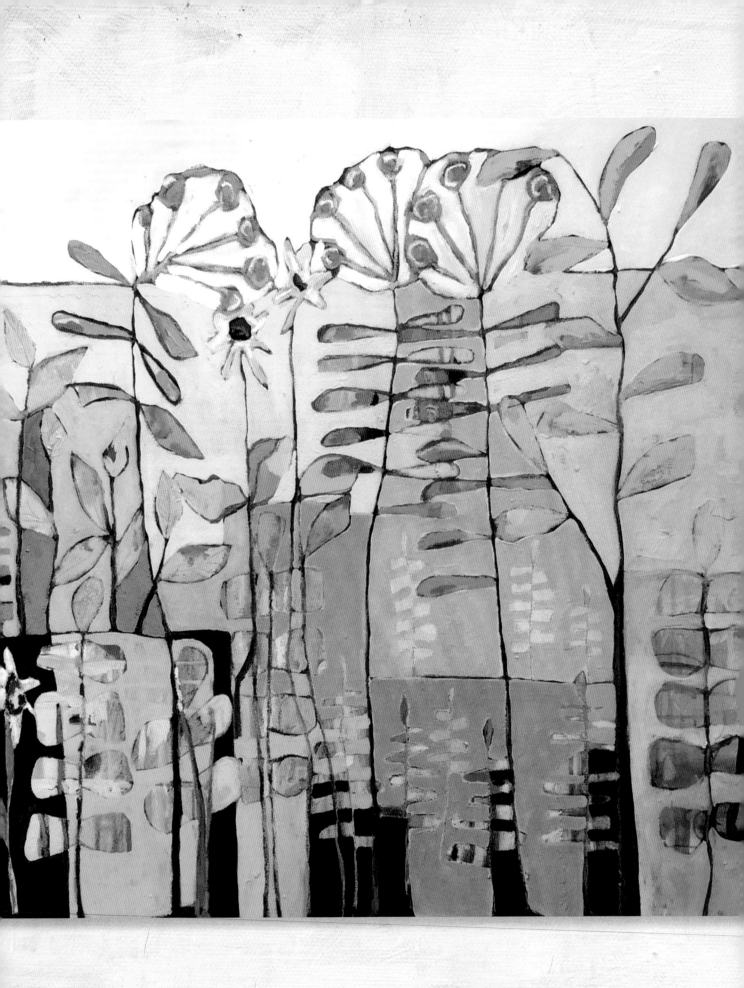

# CHAPTER 8

## Deliveries

After spending so much time completing such personal and lovely artworks, naturally you will want to share them with the world! Rather than taking that painting to a framer straight away, there are a few techniques you might consider to finish the edges of your panels or canvas on your own. Soft metallic finishes can really amp up your pieces, especially if you tend towards a more pastel color palette as I do. The contrast of shimmer and shine next to soft blues, for instance, can really bring a piece to life. Personally I love the look of copper and its soft luster. In folklore copper represents love, and really, who doesn't want to share more of that with the world! Following are ideas for sealing your paintings as well as a few ways in which copper and the copper color can be used to finish your masterpieces.

# Copper Tape

This is a simple technique that provides a subtle shimmer to your edges. The copper tape is used for stained glass projects to wrap the glass before soldering. It comes on a roll and you need to remove the paper backing to reveal the adhesive. The tape can be used alone or with copper glaze and paint. When used on canvas it looks nice applied along the edge peaking up just over the top of the painting. Used on the edge of cut wood it can really finish off sanded edges for a sleek look. It is available in a variety of widths so you can really customize your own personal style.

## GRAB IT!

copper glaze or copper paint thinned with water

copper tape ⁵⁄₁₆" (8mm) wide

red acrylic paint

soft brush roughly as wide as the edge of the canvas

soft rag or paper towel

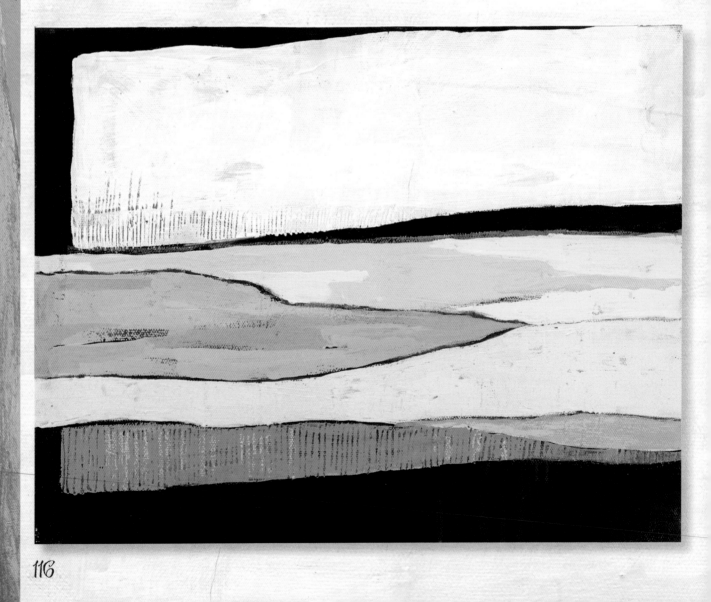

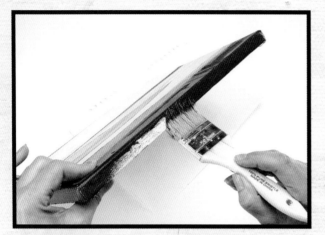

## 1 Paint the Edges

Once your artwork is completely dry use a brush to carefully paint the four outside edges of the canvas using the red paint. Take care not to get it on the front. The tape will straighten out any wobbly lines later. Allow to dry completely.

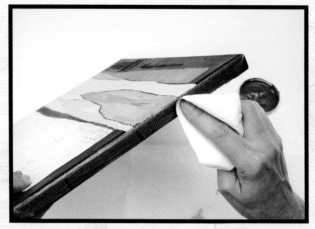

## 2 Glaze the Edges

Using a rag or paper towel, dip a corner into the glaze and rub it on top of the painted edge. You can adjust the level of shimmer by how hard your rub the glaze. Continue until all edges are complete.

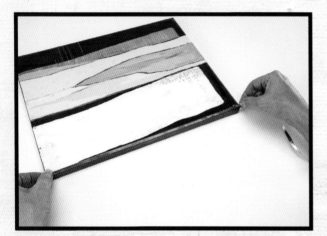

## 3 Measure the Copper Tape

Measure off enough copper tape to go all the way around all four edges of your canvas and tear it off the roll.

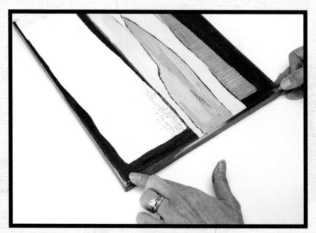

## 4 Attach the Copper Tape

Remove about 6" (15cm) of the protective paper backing and begin attaching the tape to the very edge of the painting, covering the seam where the red glaze meets the front of the painting. Rub the tape securely onto the canvas using your fingernail or the back of a spoon.

Continue removing small amounts of paper backing while you attach the copper tape onto the canvas until the entire piece is completed.

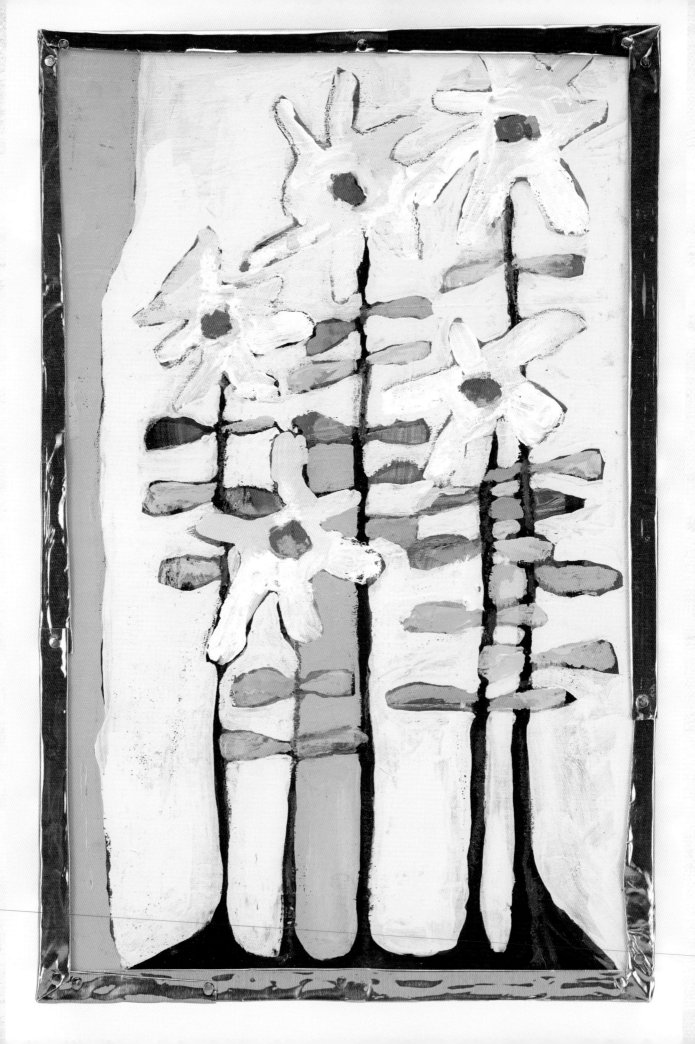

# Copper Foil

This product is primarily used for embossing. It is a thin-gauge metal product that comes in a variety of colors. There is a two-tone product available with silver on one side and a color on the other. It is sold in rolls or in sheets. For finishing edges on paintings I buy the rolled product as it is more economical and I have more control over the size of my cut pieces. Experiment using it smooth and plain or with designs embossed into it using a dull pencil. Small copper nails used to nail it into place finish the effect.

## GRAB IT!

38-gauge tooling foil

decorative metal ceiling tile nails in copper (sold in home improvement centers and online)

dull pencil or embossing tool

old scissors (the tin will dull them!)

old spoon or wooden burnisher

ruler or measuring tape

small hammer

### 1 Measure the Board

Measure the height of your board or canvas, then add an inch (25mm) so you have extra to fold under. Then measure the length of the side of your piece for the length of the strips.

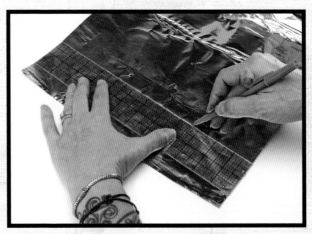
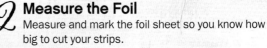

### 2 Measure the Foil

Measure and mark the foil sheet so you know how big to cut your strips.

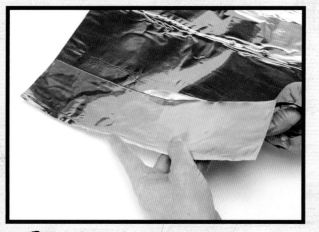

### 3 Cut the Foil

After marking the measurements, cut the strips of foil. Make sure you aren't using nice new scissors. The foil can dull the scissors.

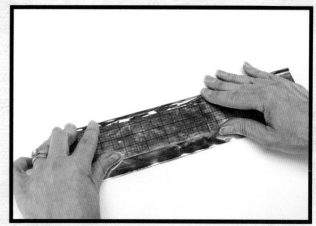

### 4 Fold the Edge of the Foil

Gently fold under ½" (13mm) along one long side of the foil. Smooth the crease using a spoon or burnishing tool. Repeat for all strips of foil.

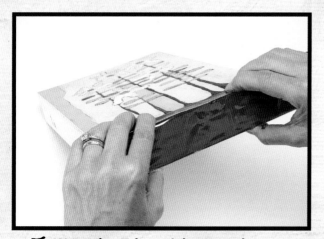

### 5 Wrap the Edge of the Board

With the finished edge on the top of the board, press the foil sheet onto the board.

## Adding Design Details

If you want to add embossed designs to your foil, do it before wrapping the foil around the piece. Place the foil, front side down, onto a stack of papers such as a magazine or newspaper. Draw designs using a dull pencil or embossing tool.

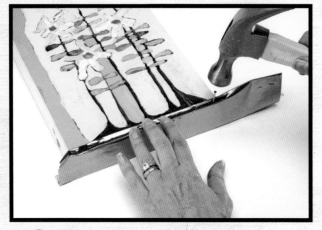

## 6 Affix the Foil in Place

Use copper nails along the edge to affix the sheet in place.

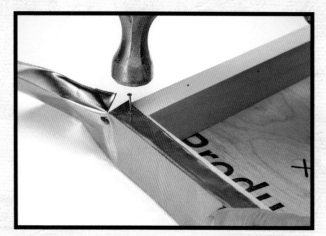

## 7 Affix the Back

Add a nail on the back of the board as well to secure the back edge of the foil sheet.

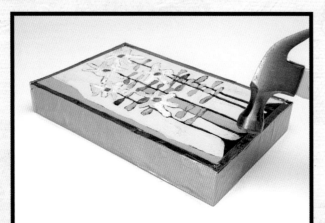

## 8 Finish Placing the Foil

Continue working around the canvas, folding and nailing the foil strips into place until the entire edge is covered.

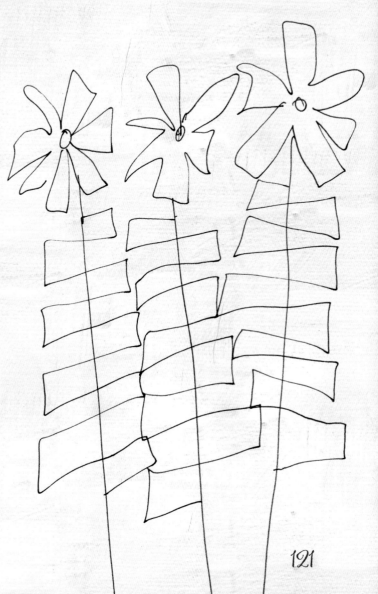

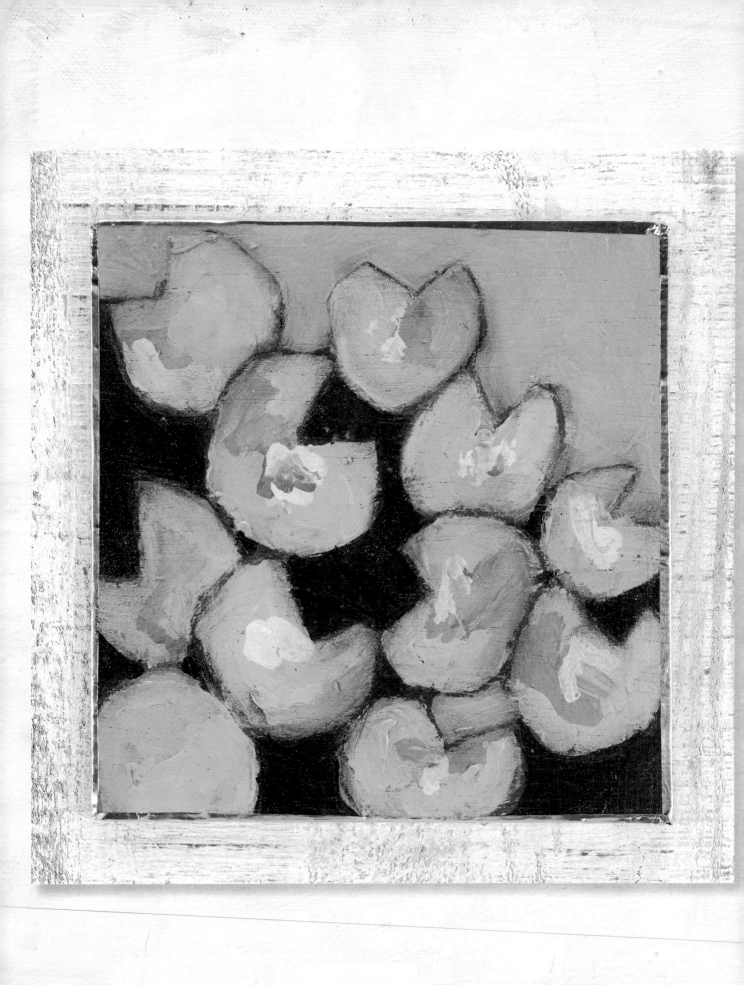

122

# Mounting on Reclaimed Wood

There is no denying the allure of vintage reclaimed barn boards or the textured striped patterns of rough-cut pine "skins." Pine skins are thinly cut (¼" [6mm]) long pine boards that are used for paneling. They often still have the bark attached and can be quite rough in texture. Running over the surface with a palm sander or sandpaper removes the small wood fibers and brings out the grain. You can leave the wood plain, go over it with a clear coat sealer, or stain it to a color of your choice. Barn boards can be livened up with a thin whitewash followed by a light sanding for a real vintage look. Use wood glue to attach the painted piece to the wooden panel.

## GRAB IT!

copper tape

finished artwork

large brush

palm sander or sandpaper

white acrylic paint

wood glue

wooden panel

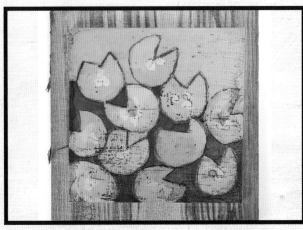

### 1 Make Sure It Fits

Find a finished piece that you want to mount onto the piece of wood. You can lay it down and see how it fits and if you need to trim the wood at all.

### 2 Personalize the Color

Paint a white wash over the wood. Let dry.

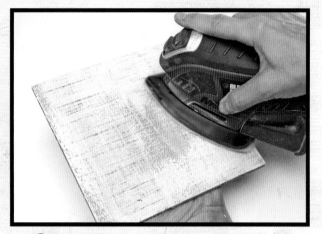

### 3 Smooth It Out

Lightly sand off some of the white paint to rough it up and show more of the wood.

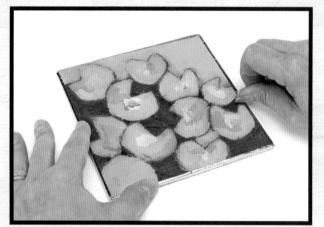

### 4 Add Some Sparkle

Add copper tape around the edges of the piece to give it a nice polished finish.

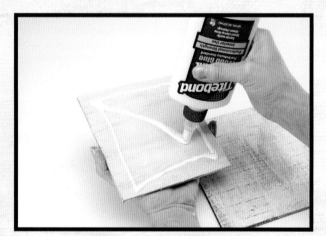

### 5 Add Wood Glue

Apply wood glue to the back of the painted piece.

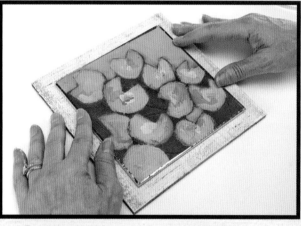

### 6 Attach the Artwork and Wood Together

Adhere the painted piece to the wood and let it dry.

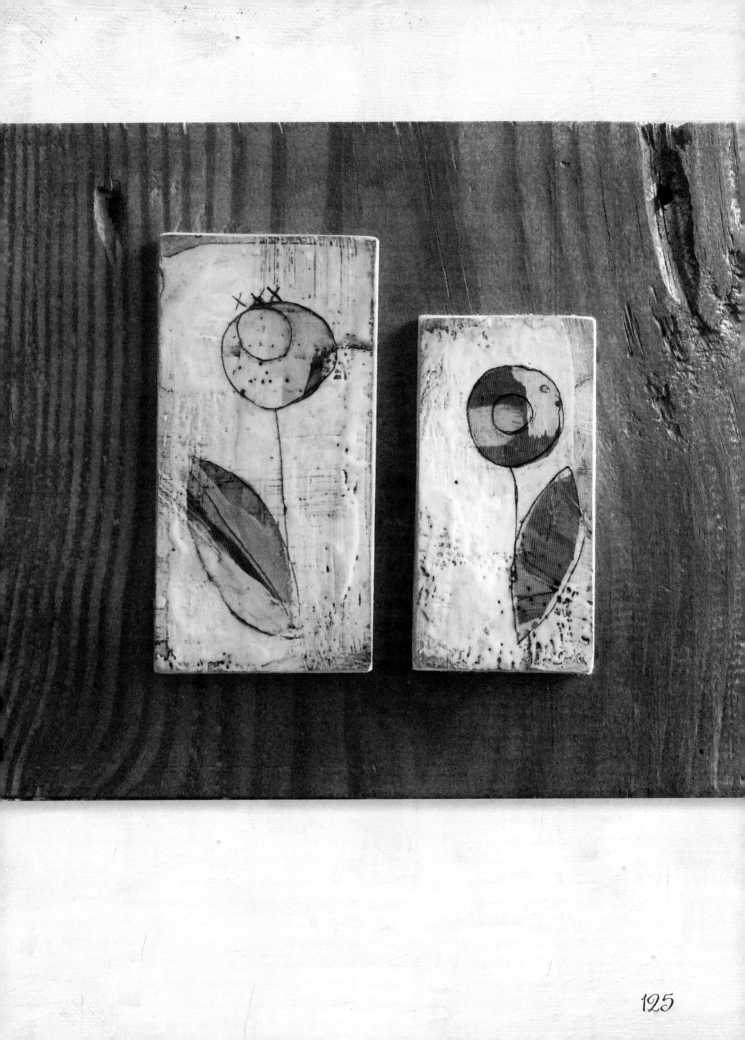

# CHAPTER 9

## Voices

I will admit it. I am an art junkie. I love perusing other people's creations and taking it all in. I usually start out by standing far away and absorbing the initial big picture, then I get right up close to it so I can see all of the teeny details, then I back up again and take another look putting it all together, the tiny and the grand. There really isn't any particular aspect that draws me to a particular piece of art or artist, but rather it's a general sense of confidence in the artwork. Pieces that look effortless yet complicated always give me pause. When the artist has found his own voice and is creating artwork that is unique and personal, as far as I'm concerned, that's a home run.

Here are a few artists who work in their own individual styles, telling their own personal narratives through visual mediums. I asked them to answer three questions about their artwork, and following are their answers and some examples of their signature style.

1. What are the recurring themes in your artwork and how are they personal to you?
2. If you could give any advice to an artist striving to make their artwork more personal, what would that advice be?
3. Are there any techniques you are willing to share that you use to allow your artwork to evolve on its own rather than push a prescribed outcome?

# Lillie Morris

Many of my paintings celebrate ancient cultures . . . reflecting a reverence for sacred cultural history that lies buried within the landscape. Ireland is a place I have visited annually since 2000. The Irish landscape is a living landscape in every sense of the word: geological, archaeological, historical and spiritual. There is a unique sense of mystery and spirituality that I seem to encounter only in Ireland. At home in Georgia, the history of ancient Native American culture resonates with me in a similar way, evoking a deep sense of reverence. I find the parallels between the ancient Irish and ancient Native American cultures striking, and the beauty of both can only be appreciated by literally and figuratively digging beneath the surface.

Paint what you truly know, and truly get to know what you want to paint! The closer you get to a subject, whether it be a flower, a figure or an entire culture, the more you will discover and the more meaningful your work will be.

I believe I am my most creative when I work intuitively, allowing inspiration to trump perspiration. Trust your gut. Go with those aha moments! Listening to music helps me tremendously, and I definitely do my best work in solitude.

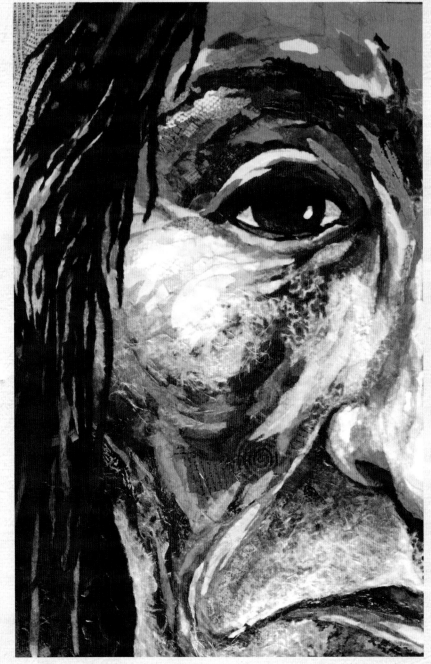

**Resident - Stallings Island Revisited**
30" × 20" (76cm × 51cm)
Collage

"The closer you get to a subject, the more you will discover and the more meaningful your work will be."

**Somewhere in Ireland**
20" × 16" (51cm × 41cm)
Collage

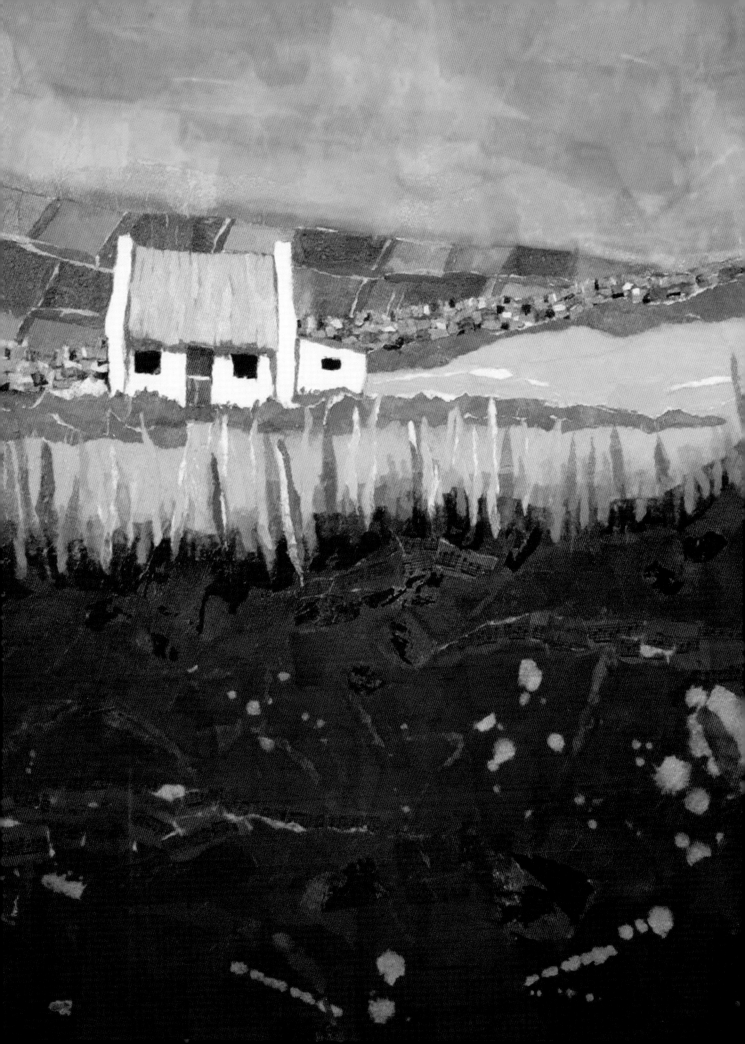

# Declan Konesky

Just do. Make good work and bad work. Push them both. Work constantly. The more you work, the deeper you'll have to dig in order to create. Before you know it, your work will have elements of you that you didn't know you had or didn't realize were important. Personally, working like this gives me peace and freedom. This is especially true within my art. I felt free to express anything and everything. Sometimes the work is good and sometimes the work is bad. But you need all of it if you want your work to be any bit personal.

Getting work to evolve and avoid stagnation is a lot like skydiving. You just have to go for it. Jump in. Make a mess. Create problems. Make bad work worse. Then go fix it. I have so many projects going on at once that I simply can't put too much focus on them all, so naturally some have a drastically different feel simply because my approach to them is intuitive, lacking any and all logic. I can go back to them, play with them, rediscover something and ultimately use it for later. The important thing though is to just keep working. Work through the slow periods, the periods where you don't feel creative or motivated. This is when you learn to just jump bravely, where you learn to respond to the work and let it guide you, rather than the other way around. You know you're doing it the more often you end up surprising yourself.

**Untitled**
20" × 20" (51cm × 51cm)
Watercolor on cotton rag

**Untitled**
20" × 20" (51cm × 51cm)
Watercolor on cotton rag

"Make a mess. Create problems. Make bad work worse. Then go fix it."

**Untitled**
20" × 20" (51cm × 51cm)
Watercolor on cotton rag

**Untitled**
20" × 20" (51cm × 51cm)
Watercolor on cotton rag

# Jay Jacobs

This particular style of my painting has its origin in the summer vacations my family would take to a tree farm on a tidal river in the low country of South Carolina. The cabin we stayed in was remote, and at night the five-year-old version of me would try to distract myself from being scared of the dark by using my imagination to turn the knots in the heart pine walls into silly faces. This kind of drawing, with my imagination and a night light projected on a piney wall, ultimately became the way I drew with crayons on paper and eventually paint on canvas. Over time I have learned to incorporate other influences and themes into this template, but the root style has remained and is very identifiable by the ellipses, circles and eyes prevalent in these paintings that all harken back to the knots on the pine walls in that cabin. Being self taught I have disciplined myself in many different styles of painting, but this particular one is revisited the most, probably because it's the most cathartic, automatic in its construct, and a direct link to how I related to the world as a child.

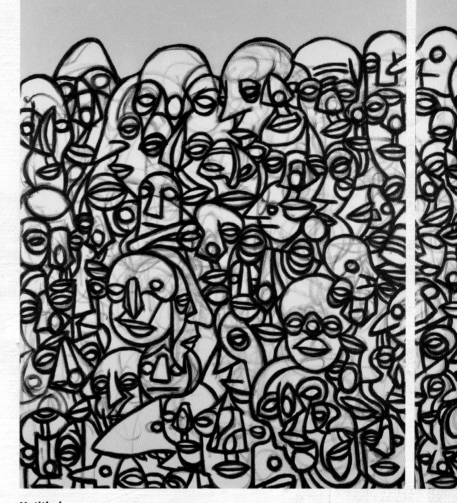

**Untitled**
48" × 108" (122cm × 274cm), triptych
Acrylic on canvas
Photo by Ron Vaz

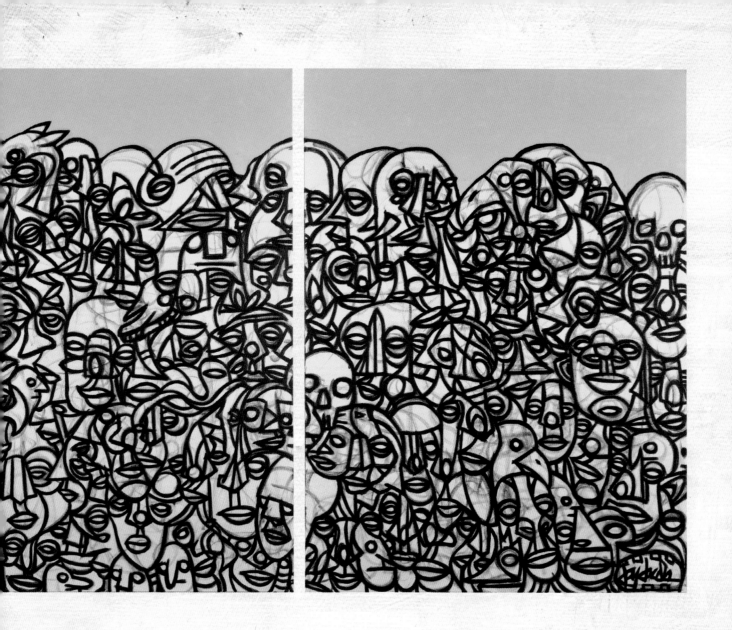

"...because it's the most cathartic, automatic in its construct, and a direct link to how I related to the world as a child."

# Cindy Wunsch

The recurring themes in my artwork are images that represent healing, a sense of hope and the inner spirit. I use the artistic process as a way of connecting to my higher power and a way of connecting with the hearts of those who see or collect it.

In an effort to make artwork more personal, I think it is important to call on your inner child. Leave judgement somewhere else and break the rules. Play.

I think my artwork has evolved because I spend lots of time doing it. Like anything else "practice, practice, practice." The more I paint, the easier it is for me to access my creativity. I don't have to think about it as much; the art somehow just shows up. My creative self stands beside me rather than me having to run around and look for it.

"My creative self stands beside me rather than me having to run around and look for it."

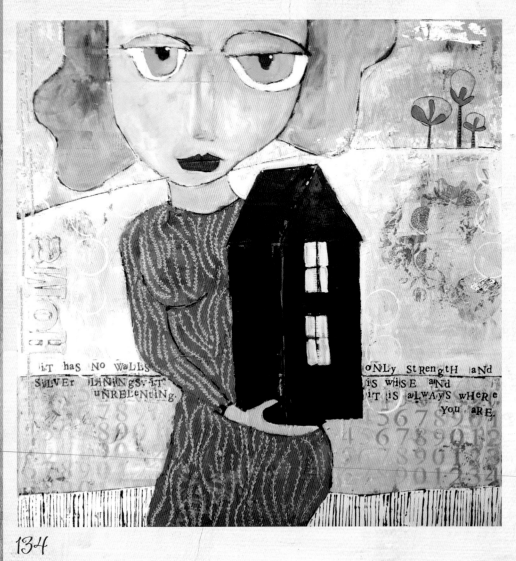

**Home**
36" × 36" (91cm × 91cm)
Mixed Media

134

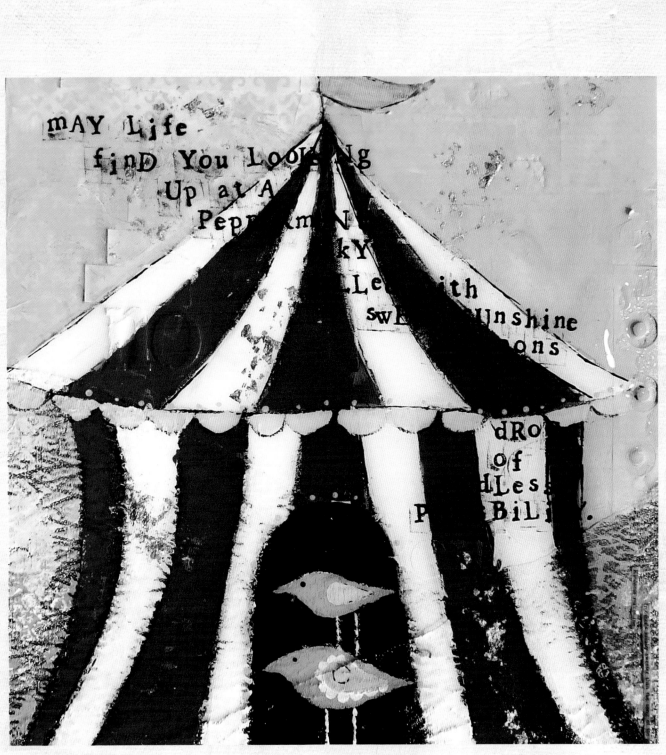

**The Tent**
20" × 20" (51cm × 51cm)
Mixed Media

# Chase Lanier

My work has developed into a presentation of thousands upon thousands of brushstrokes to compose a picture. Each brushstroke represents for me a part of a bigger whole. This has a correlative to water particles creating a wave, individual people creating a population, birds in a murmuration. I'm compelled by the action of the whole progressing by the collaboration of the parts. Through language, community and respect, the result of harmony is feasible. I explore these ideas visually in my art as a way to practice awareness to these patterns in the hope of applying them in life away from the easel.

Be honest with what intrigues you and let it consume you. Seek definition and understanding through the art of play with the parts that excite you. For me, color and form are my aesthetic playmates. Like making friends, gravitate towards what you like and spend time with it. If a part bores you, find a new one. Some will stick with you forever.

Find your process. Try anything, though recognize what enhances your experience and do that more. Challenge yourself to figure out how something works if you really like its look. Everyone has their particular way of working that is comfortable. That has changed for me over time. I labored painstakingly for years. I've now begun to move fast as if catching a wave and finishing a piece before crashing into the shore. Knowing the view of my end product proved detrimental to the process. Having an open-ended approach has been fruitful and rewarding. By not deciding what the painting will look like, I am open to inspiration in the moment. I can then accept that something is lacking, and shift, add something new, and it's back on track just like that.

**Se Chanj**
24" × 24" (61cm × 61cm)
Oil on panel, 2014

"By not deciding what the painting will look like, I am open to inspiration in the moment."

**Stark Flux**
24" × 24" (61cm × 61cm)
Acrylic on panel, 2015

**Pillar**
32" × 32" (81cm × 81cm)
Oil on panel, 2014

# Natalia Bowdoin

The themes I am most drawn to have to do with relationships. Relationships between people. Relationships between people and the natural world. Relationships between people and animals. I am also very interested in language, text and the visual representation of language. These themes are most personal to me primarily because of my time spent living overseas in central Africa and China where the patterns and flavors of relationships (in all the manifestations mentioned above) were very different than those most familiar to me as an American. Additionally, being required to use and think in different languages has made me fascinated with our process of labeling and naming and the linguistic forms we use to do that, particularly when they manifest in visual ways, whether through writing or the use of symbols.

My advice to anyone who would like to work more intuitively is to let go of the idea of being "an artist" and focus instead on the actual act of looking and the playfulness of creating. When I become focused on the label of "artist" or "being a painter," I lose sight of the joy of just experiencing the world in a visual way, and my artwork becomes stiff and often uninteresting. If I focus instead on experiencing the process of experimentation and really try to see what is emerging from the piece itself, the final work has much more energy and originality.

One technique I enjoy very much involves brushing molten wax on top of the image I have painted. After the wax has hardened I carve into the wax and then apply waterproof black India ink over the surface. After the ink has dried I then remove some of the ink with mineral spirits. This process inserts a certain spontaneity into the piece, and something always emerges in the painting that I had not planned or foreseen. The final painting is often very much improved by this element of chance. I finish the piece with an application of either straight gloss varnish or a mix of gloss and matte varnish.

**Self Portrait as Wood Duck**
16" × 20" (41cm × 51cm)
Acrylic, wax, ink on wood

"If I focus instead on experiencing the process of experimentation and really try to see what is emerging from the piece itself, the final work has much more energy and originality."

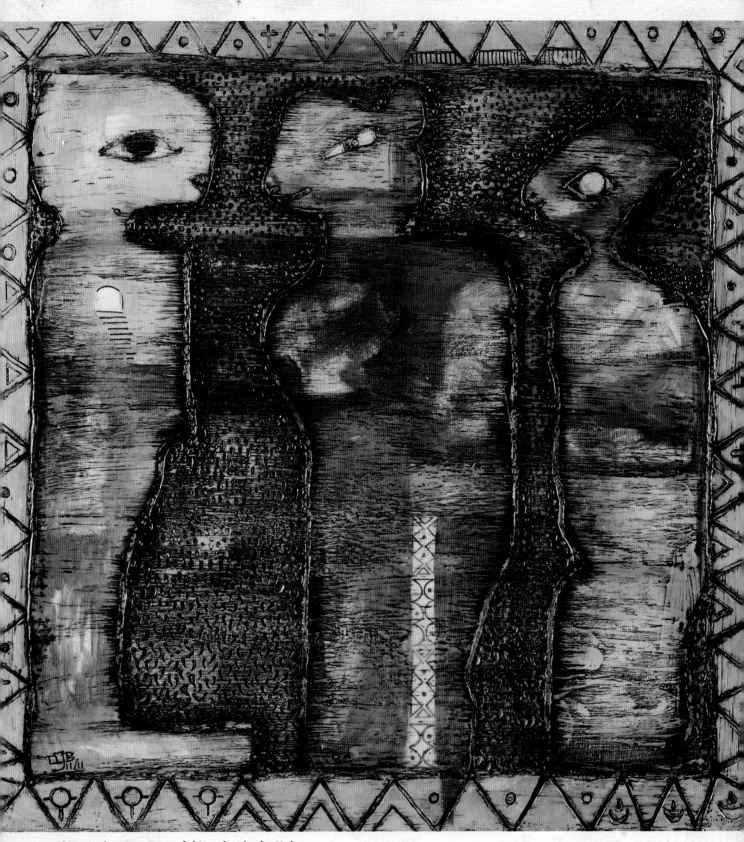

**Three Is the Most Powerful Number in the Universe**
24" × 24" (61cm × 61cm)
Acrylic, wax, ink on wood

# Index

a content + ecommerce company

Other fine North Light Books are available from your favorite bookstore, art supply store or online supplier. Visit our website at fwcommunity.com.

20  19  18  17  16    5  4  3  2  1

DISTRIBUTED IN CANADA BY FRASER DIRECT
100 Armstrong Avenue
Georgetown, ON, Canada  L7G 5S4
Tel: (905) 877-4411

DISTRIBUTED IN THE U.K. AND EUROPE
BY F&W MEDIA INTERNATIONAL LTD
Brunel House, Forde Close, Newton Abbot, TQ12 4PU, UK
Tel: (+44) 1626 323200, Fax: (+44) 1626 323319
Email: enquiries@fwmedia.com

ISBN 13: 978-1-4403-4448-0

Edited by Beth Erikson
Designed by Geoff Raker
Production coordinated by Jennifer Bass

# About the Author

Producing exceptional fine art inspired by craft, Aiken, South Carolina, painter Staci Swider's work reinterprets the patterns and textures found in function-driven objects such as quilts and baskets as dreamscape imagery that straddles the line between figurative and abstract.

Swider's visual history includes stints as both a corporate and freelance textile designer, professional painter and author. Her work has been exhibited at the Morris Museum of Art as well as many galleries across the Southeast.

Find more of Staci's work at **staciswider.com**.

## Metric Conversion Chart

| To convert | to | multiply by |
|---|---|---|
| Inches | Centimeters | 2.54 |
| Centimeters | Inches | 0.4 |
| Feet | Centimeters | 30.5 |
| Centimeters | Feet | 0.03 |
| Yards | Meters | 0.9 |
| Meters | Yards | 1.1 |

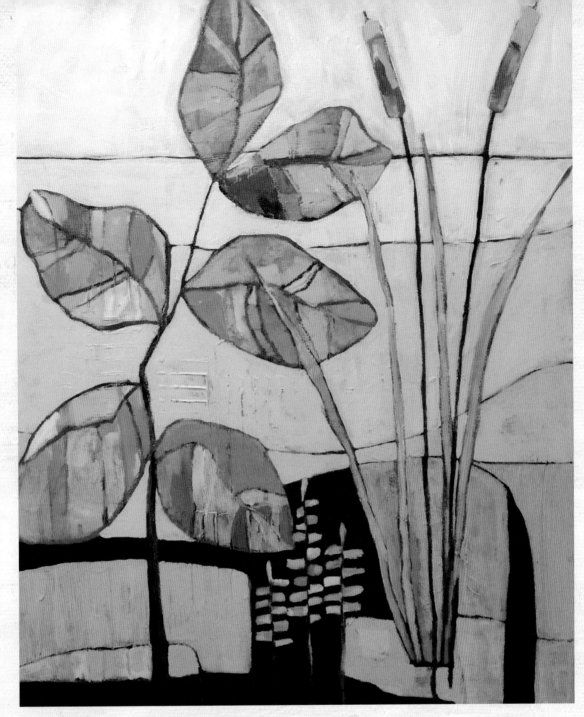

# Acknowledgments

I would like to thank my editor, Beth Erikson, for holding my hand throughout this process, Christine for her photography skills and patience, Tonia Jenny for believing in my vision, all of the talented artists featured in the Cast of Characters: Andrea Kulish for her beautiful pysanky, Holly de Saillan for her charming rabbit sculptures, the Polish artists for their motanka dolls. I would also like to thank my husband and children for hanging in there while I worked, and most of all, my best friend, Jenny Wright, for listening to my seemingly endless phone calls sorting through creative inspirations, trials and meanderings. You are all precious to me. XO

# Dedication

For my family and friends who hold me up.

**Download a free bonus demo at artistsnetwork.com/ acrylic-expressions.**

# Ideas. Instruction. Inspiration.

Receive FREE downloadable bonus materials when you sign up for our free newsletter at artistsnetwork.com/Newsletter_Thanks.

Find the latest issues of *Acrylic Artist* on newsstands, or visit artistsnetwork.com.

These and other fine North Light products are available at your favorite art & craft retailer, bookstore or online supplier. Visit our websites at artistsnetwork.com and artistsnetwork.tv.

Follow North Light Books for the latest news, free wallpapers, free demos and chances to win FREE BOOKS!

# Get your art in print!

Visit artistsnetwork.com/competitions for up-to-date information North Light competitions.